STANLEY
SOUTH MOOR
& CRAGHEAD
THROUGH TIME

AMBERLEY PUBLISHING

First published 2009

Amberley Publishing Plc
Cirencester Road, Chalford,
Stroud, Gloucestershire, GL6 8PE

www.amberley-books.com

Copyright © Ron Hindhaugh, 2009

The right of Ron Hindhaugh to be identified as the
Author of this work has been asserted in accordance
with the Copyrights, Designs and Patents Act 1988.

ISBN 978 1 84868 666 3

British Library Cataloguing in Publication Data.
A catalogue record for this book is available from
the British Library.

Typeset in 9.5pt on 12pt Celeste.
Typesetting by Amberley Publishing.
Printed in the UK.

Introduction

Stanley has had a variety of spellings over the years including Stanleigh, Stanlaw and Standley. The name Stanley is thought to mean Stony Field or Clearing and comes from the old English *Staenig-Leah*. The town can trace its history back to the Romans who built a raised road or causeway from Stanley to their forts in Newcastle and South Shields. Various notable families have owned or held the Manor of Stanley through the years. The descendants of William de Kilkenny, an Irish clerk, held the manor for six generations. The manor has also been held by Thomas de Birtley, the Tempest and Townley families.

The existence of the Stanley we know today did not come about until 1832 for it was in this year that the West Stanley Colliery was sunk. Prior to this Stanley Front Street was bordered by hedges and trees and known as Shield Row Lane. However by 1910, to quote *Kelly's Directory of Durham*, 'The district is entirely dependent on the coal mines, and there are six collieries in full work in the parish, viz :- Air Pit, Mary Pit and East Stanley Pit, owned by Messrs James Joicey and Co. Limited; the Louisa Pits (old and new), belonging to the South Moor Colliery Co. Limited; the West Stanley Colliery and the West Shield Row Colliery, which the property of the South Derwent Coal Co. Limited.'

Accidents at these collieries were not unknown and the worst took place at the Burns Pit in February 1909, when 168 (the same number as there are on a set of dominoes) men and boys lost their lives.

South Moor, also a mining village, was originally in the Parish of Lanchester but later, in 1865, became part of Holmside Parish. Coal had been worked in the area from at least 1726 when a Newcastle merchant named Thomas Ord sank a pit called Ords Main. However, it was the sinking of deep mines that drew men from around the country to the area.

The West Craghead, later South Moor, Colliery (the Billy Pit), sunk by William Hedley in 1839, was one such pit. Others included the New Shield Row — later Quaking Houses Pit but always referred to as the Charley Pit — sunk in 1845 and the Hedley Pit, sunk in 1885.

Like Stanley and South Moor, Crag Head (it did not become Craghead until the 1920s) is also a mining village and, like its neighbouring villages, it owes its existence to the deep mines that were sunk in the nineteenth century, the first of which was the William Pit sunk by William Hedley in 1839.

William Hedley came to Craghead from Wylam Colliery where he had made his name as an inventor. It was while he was at Wylam that he built the Puffing Billy and the Wylam Dilly. These were early working steam locomotives that hauled coal on the Wylam railroad.

After William's death in 1843, his sons, collectively called Thomas Hedley Brothers, took on the management and sinking of the collieries in Craghead with another five pits being sunk between 1841 and 1916. Indeed, it was William's third son, also called William, who was responsible for the building of both the school and the institute in Craghead.

The collieries that were for so long the lifeblood of the area have long gone. Industrial estates and housing estates have been built on some of these derelict colliery sites. Stanley now has a busy market on Thursdays and Saturdays. New sporting facilities have been built and a new school academy is planned.

Life goes on in all three of these former mining villages.

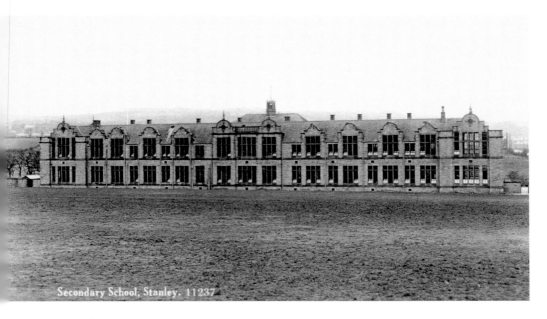

Secondary School, Stanley. 11237

Tanfield School

This is Tanfield Lea Higher Elementary and Pupil Teachers Centre, which opened 16 October 1912. Five days later, on the 21 October, the first pupils arrived. It later became The Alderman Wood School and then Stanley Grammar School, and in 1977 it was renamed Tanfield Comprehensive School when it merged with Shield Row Secondary School. Today there is a large fence around the school, which makes photography difficult.

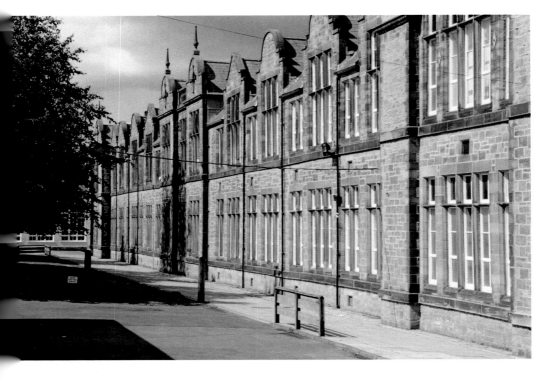

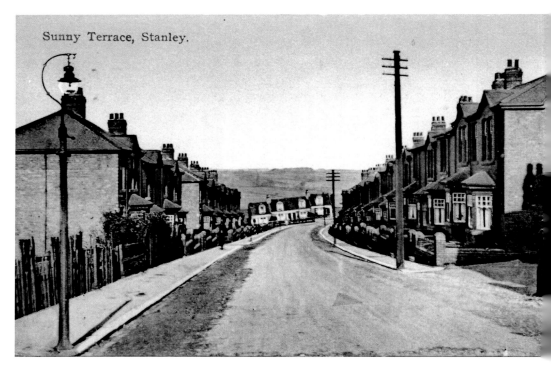

Sunny Terrace, Stanley.

Sunny Terrace
Two views of Sunny Terrace, a case of 'spot the difference' as, taking into consideration the number of years between each photograph, not much has changed.

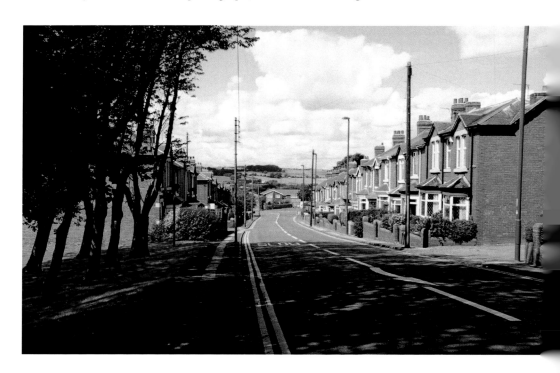

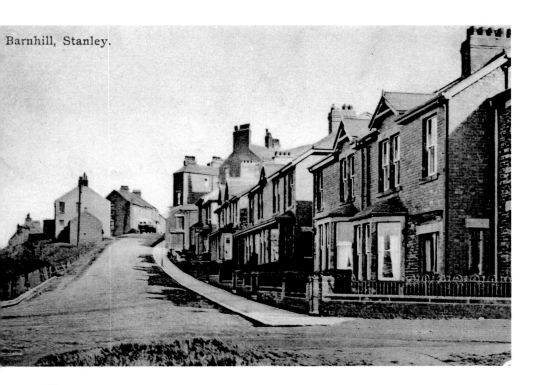

Barnhill, Stanley.

Barn Hill

It is possible that the bus shown at the top of the bank in this view of Barn Hill belongs to Hunters who still operate buses today to Stanley. I waited a while to see if another Hunters bus would come along but, unfortunately, a Go North East bus came along instead.

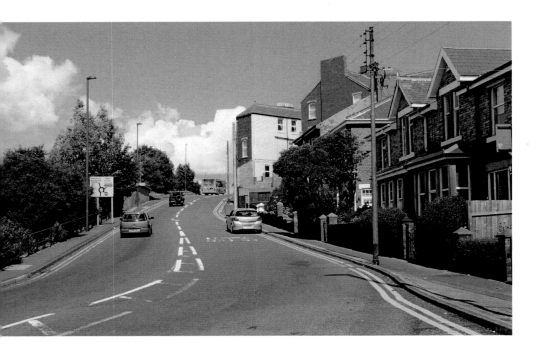

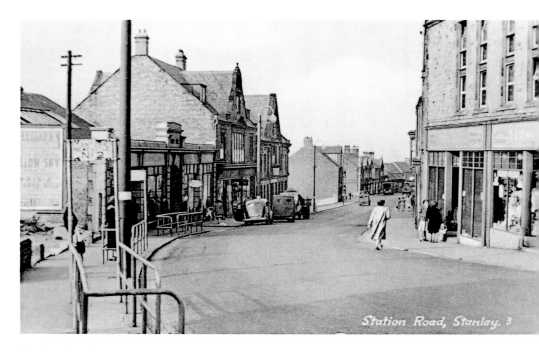

Station Road

The Market Hall illustrated on the left was built on this site in 1924. The original Paddy's Market, as it was known, had been on various sites in Stanley prior to the Market Hall being built here. It closed as a market some time ago, and it is now Stanley Market Hall Carpet Centre. Stanley Victoria Club can be seen just down the road from the Market Hall. This opened on 23 September 1911 and closed in November 1984, the building now being used as residential flats.

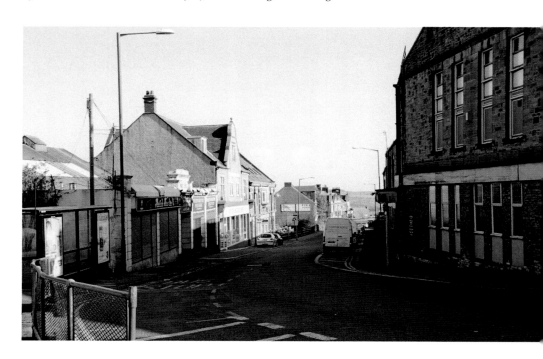

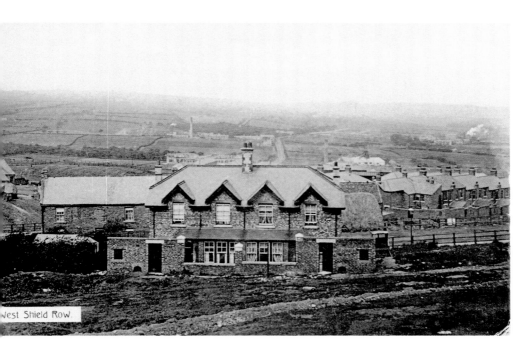

West Shield Row.

West Shield Row

This is a view of Tanfield Lea taken from Station Road. The houses in the foreground form part of Barn Hill. If trees did not obscure the view a very different landscape would be seen today. Gone are all the collieries, with housing and industrial estates built in their place.

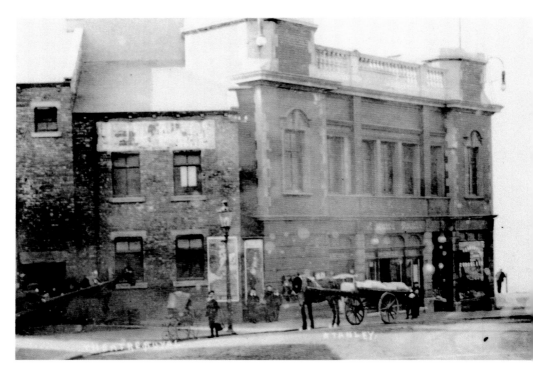

The Theatre Royal

At the turn of the twentieth century, Mr Mark H. Lindon founded the Stanley Theatre Company. The company built the Theatre Royal in Station Road, which opened in 1903. On 30 March 1930, the theatre was destroyed by a fire and had to be demolished. A bus station was later built on the site, but in May 2002 this also was demolished.

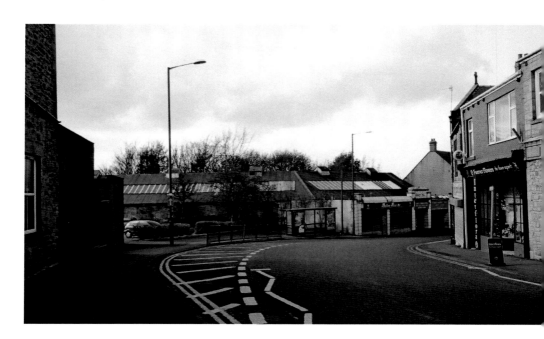

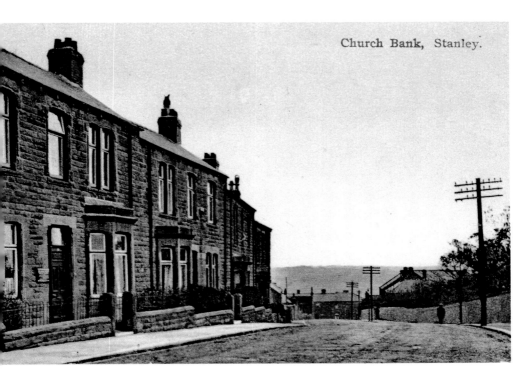

Church Bank, Stanley.

Church Bank
Like Sunny Terrace and Barn Hill very little has changed on Church Bank.

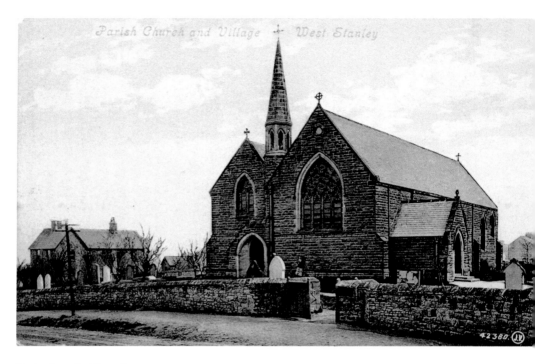

St Andrew's Church

This is St Andrew's, the parish church of Stanley. It was built in 1876 and had seating for 400 people. An organ was installed in 1880. The building of the tower took place between 1930 and 1931 and, at the same time, a set of bells was installed. It was consecrated 14 January 1931, and in 1952 a clock was installed in the tower. The spire is currently undergoing restoration.

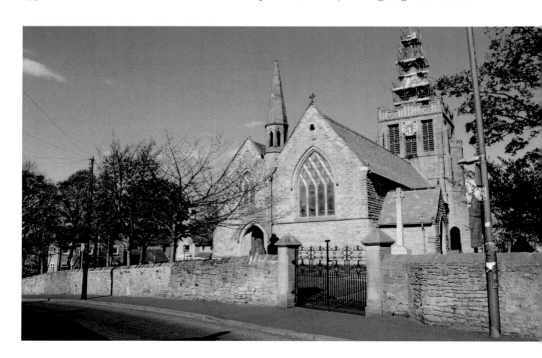

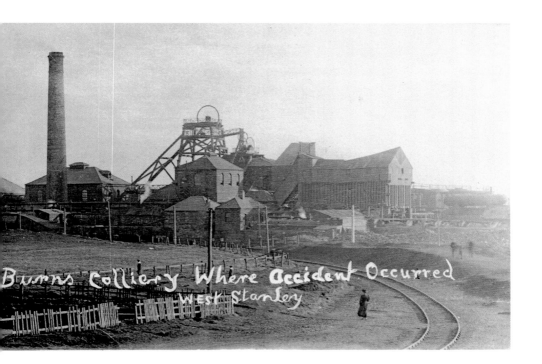

Burns Colliery Where Accident Occurred
West Stanley

Burns Pit

This is the site for what was possibly the saddest day in the history of Stanley. The Burns pit disaster occurred at 3.45 p.m. on Tuesday 16 February 1909, when 168 men and boys lost their lives in two enormous explosions. The West Stanley Colliery was sunk in 1832 and the town of Stanley grew around it. The disaster of 1909 was not the first tragedy at the colliery. Two men had lost their lives in 1865, and in 1882 thirteen men were killed in an explosion. It was not until 1933 that the last two victims were recovered from the 1909 disaster. The pit was closed 19 March 1936. The photograph shows the first memorial to the victims, which was originally erected outside the Council Offices on Stanley Front Street but was later moved to this site at the entrance to Stanley Graveyard.

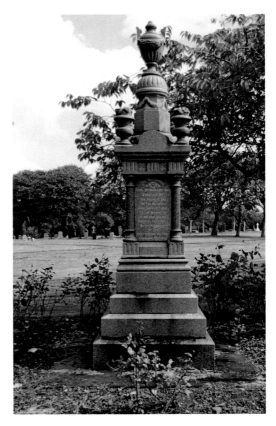

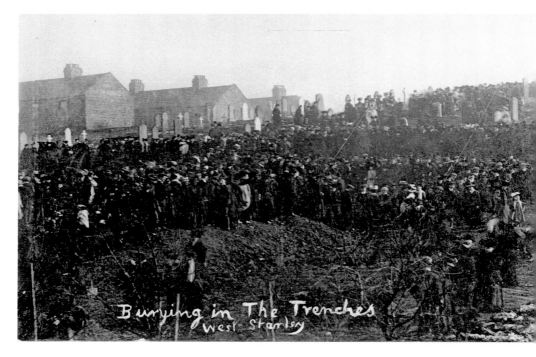

Burying in The Trenches
West Stanley

The Trench

Following the Burns Pit disaster of 1909 a number of the men and boys killed in the explosions were buried together in two trenches in St Andrew's churchyard. It was estimated that 200,000 people came to Stanley to pay their last respects to them. Another memorial stone now marks the spot where they were buried.

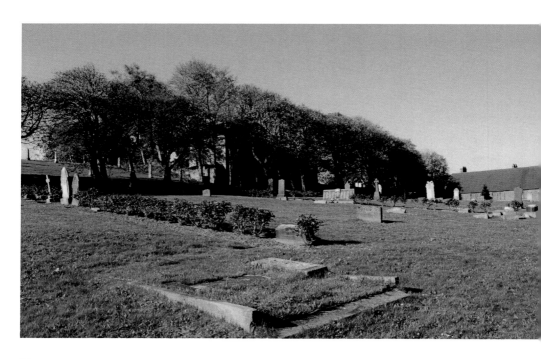

Presbyterian Church

In 1895, the Presbytery of Newcastle agreed to build a Presbyterian church in Stanley. They laid the foundation stone for the church within six years. It is now the Christ Church United Reformed Church.

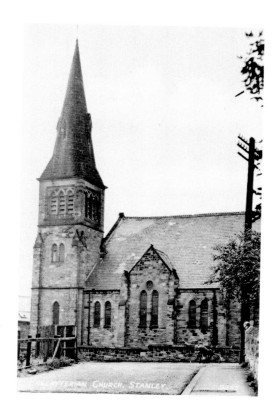

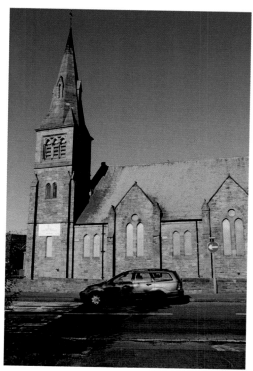

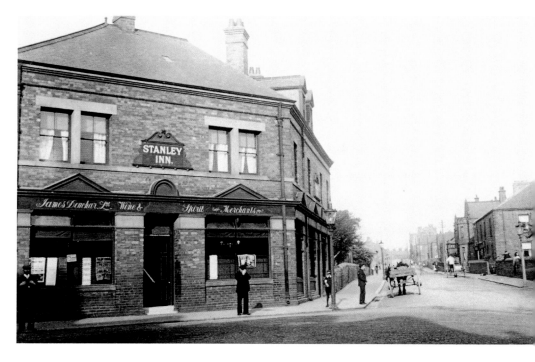

The Stanley Inn

The first public house built in Stanley was the Stanley Inn, better known as Paddy Rock's. Mr James Forster opened the Stanley Inn in around 1860. It was demolished at the beginning of the 1970s to make way for the town centre bypass.

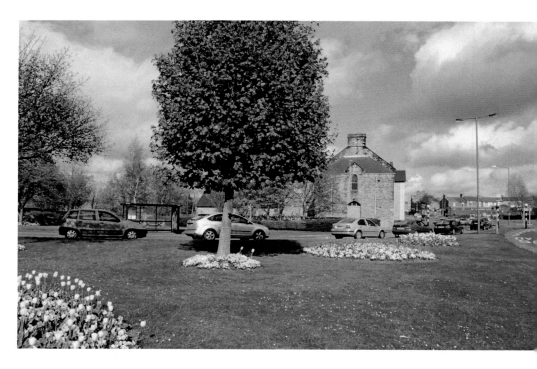

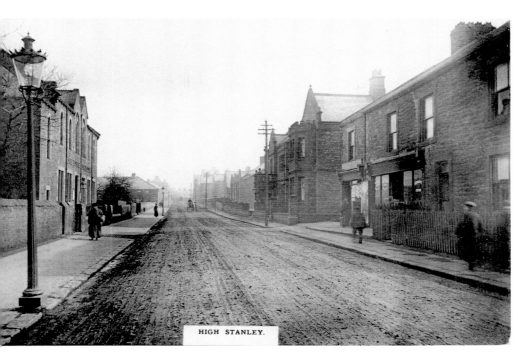

HIGH STANLEY.

High Stanley

This is the road to East Stanley in around 1910. The police station on the right was built *c.* 1894 and next door was the Salvation Army Barracks. Like Paddy Rock's, the buildings on the right were demolished in the late 1960s and early 1970s to make way for the new by-pass.

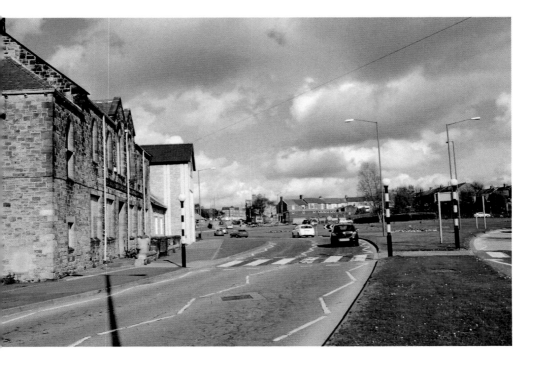

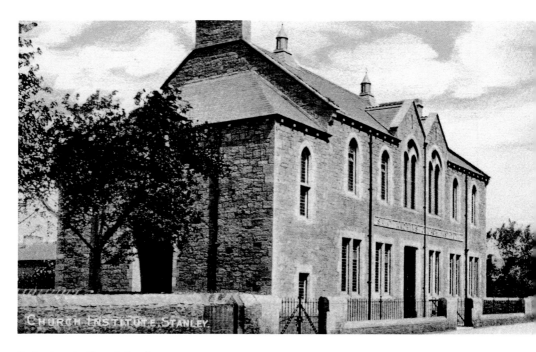

St Andrew's Church Institute

The laying of the foundation stone for St Andrew's Church Institute took place on 12 June 1893 and was opened by the Bishop of Durham on 9 July 1894. It had a billiard room, newsrooms and a library. The caretaker's house next door to the institute was erected in 1901-02, and the Police Courts were held here up to 1928. It has also been used as a school and by various groups, including the Ever Ready Brass Band and the Salvation Army. Now, as you can see, it is boarded up and disused.

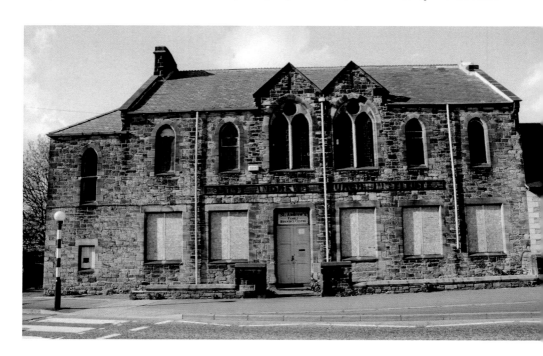

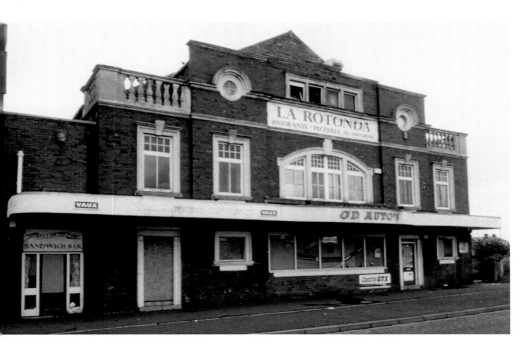

The Pavilion

This building, once the Pavilion cinema opened in 1923 and closed in 1966. It became G.D. Auto's, a car accessory shop. On the upper floor was, for a short time, La Rotonda Pizzeria. In 2001, the building was demolished and the following year the Co-operative Funeral Service opened on the site.

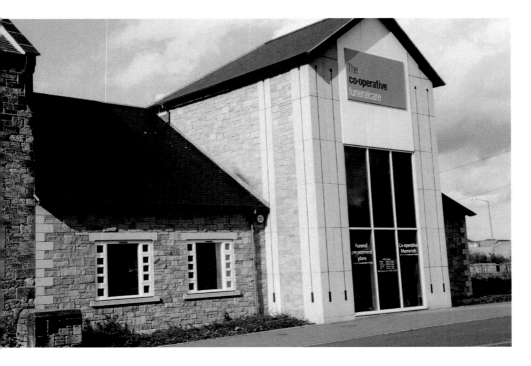

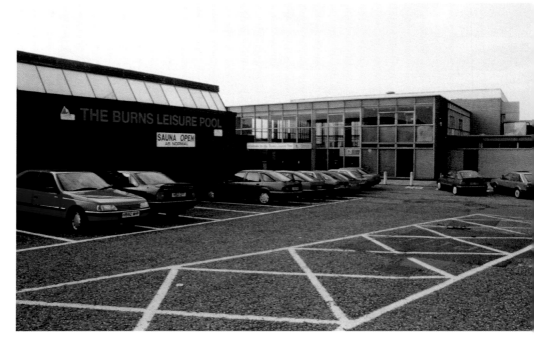

Stanley Baths

Stanley Baths, or as it was later to become, the Burns Leisure Pool, opened in 1965. It had a relatively short lifespan as it closed to the public in 1996 and was demolished a year later in 1997. The area is now used as a skate park and car park but plans are underway to build a school academy on the site. Stanley now has a new swimming pool behind the sports centre.

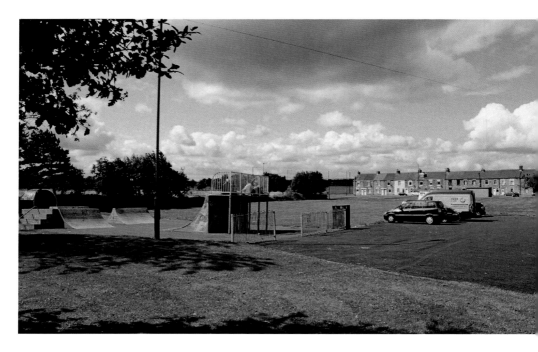

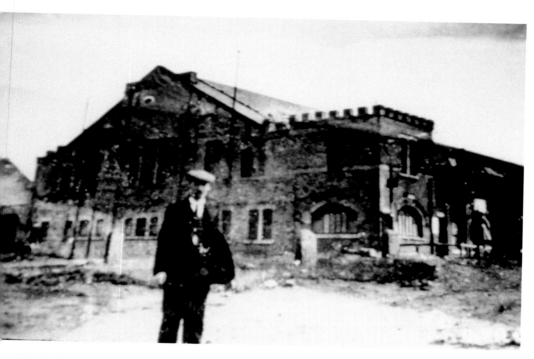

The Roller Skating Rink

Stanley's indoor roller skating rink opened prior to 1912. The newly formed Northern General Transport Company Limited acquired the building during 1914 to garage their buses, which still run from here today.

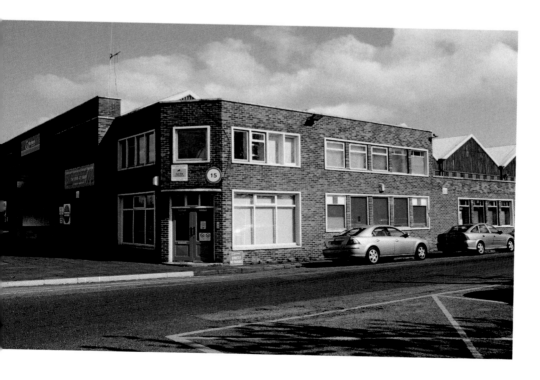

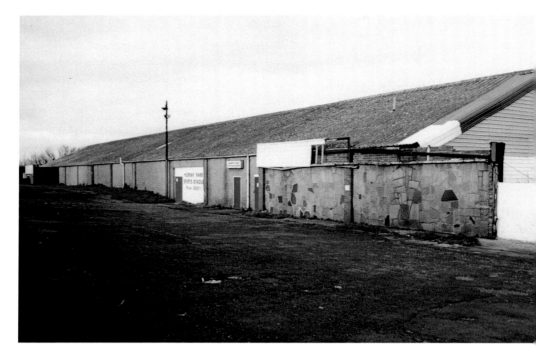

Murray Park

Murray Park opened on Thursday 27 September 1906. This was the home of West Stanley AFC. Greyhound racing was introduced in 1937 when the first greyhound race took place in the renamed Stanley Greyhound Racing Stadium. Football carried on at the stadium until 1959. In 1971 and again in 1980 the stadium was partially rebuilt following two fires, and in 1994 the stadium was to close altogether. A housing estate has now been built on the site.

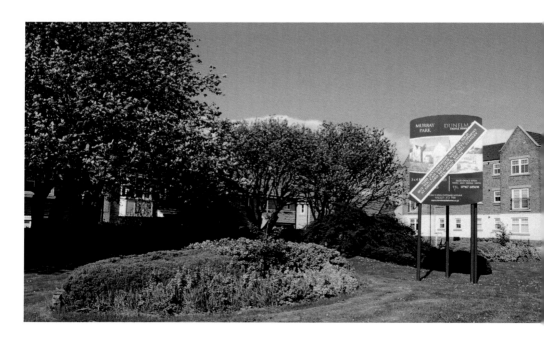

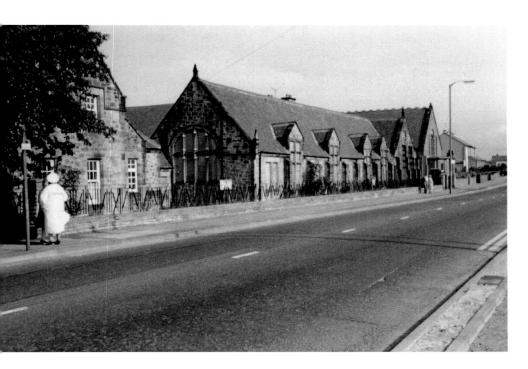

East Stanley School

The school at East Stanley was built in 1891, enlarged in 1895 and again in 1904. Sometime after the school closed it was demolished stone by stone and rebuilt, less two classrooms, at Beamish Open Air Museum where it is now a visitor attraction.

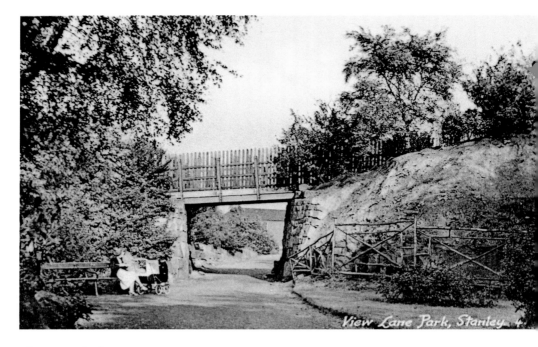

View Lane Park

Shield Row Plantation was offered by Mr D. Shafto to Stanley Council for use as a park but the offer was turned down. Later, the council decided to buy some land from Mr Shafto, and in 1914 plans were drawn up for a park. A wall was erected in 1925 with the gates being added in 1928. The park had the usual lawns and flowerbeds as well as tennis courts and a bowling green. Unfortunately, by the 1980s the park had fallen into disrepair.

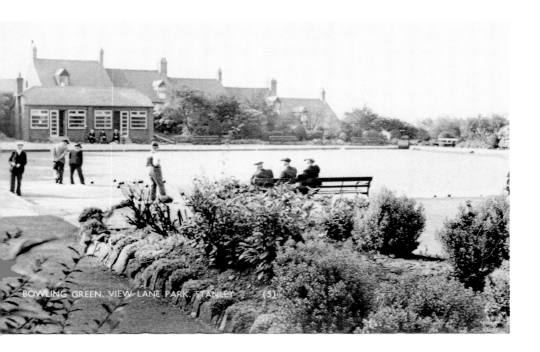

BOWLING GREEN, VIEW LANE PARK, STANLEY (5)

The Bowling Green, Stanley

The bowling and putting greens in the park at Stanley opened 26 May 1931 with an inaugural match between the council office staff and local councillors. Work is now under way to restructure the park, this being financed by a partial sell-off of part of the parkland to build a special needs health care centre.

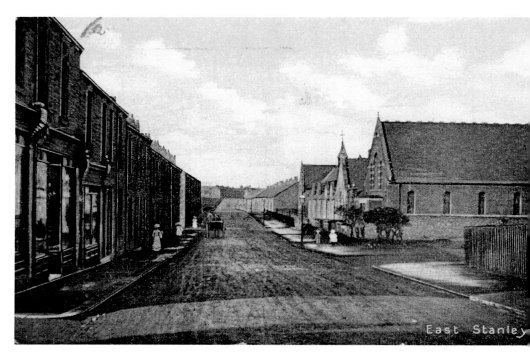

East Stanley

The Primitive Methodist Church, on the right, was built in 1897 and is still here today although in this picture it is hidden by the trees. Unfortunately, the houses that lined both sides of the road have long since disappeared.

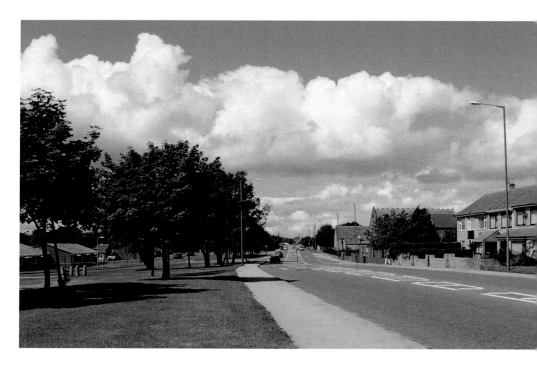

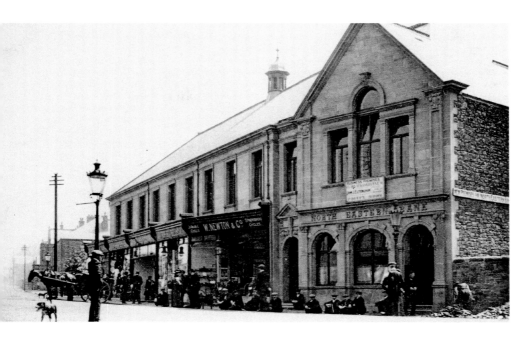

Elite Buildings

The Elite Buildings stand on the site of six houses that were demolished in 1908, which were part of Benton Terrace. In 1910, a Mr Green built this large hall and called it the Town Hall Buildings. It was, in 1912, opened as a picture house called the Elite Picture Hall and later converted into a dance hall. The Palais de Dance, as it was known, was a very popular place; it is still a very popular place today, only now the hall is used as a bingo hall.

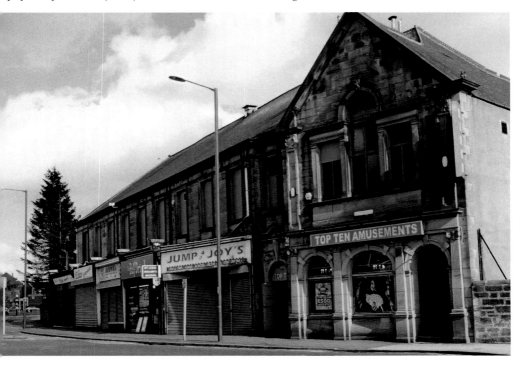

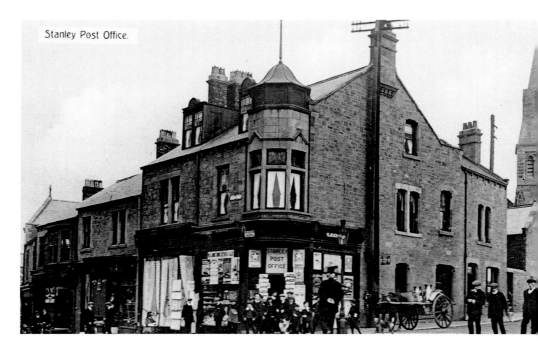

Stanley Post Office.

The Post Office

This building was built by Mr M. G. Armstrong who opened it as a post office and newsagent. Mr Armstrong was postmaster in Stanley from 1902 until he died in 1929. His eldest daughter, Mrs Cameron, took over the post office when her father died. The building has been occupied by various businesses since the post office moved to Clifford Road, including, as you can see, a hairdressing shop that has now closed.

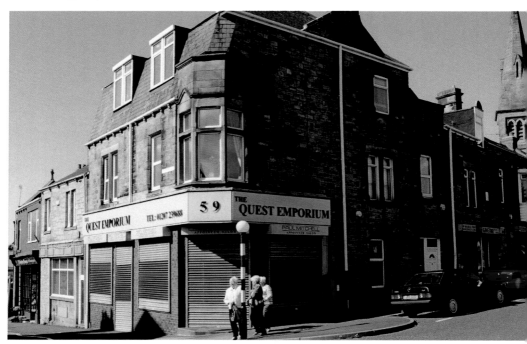

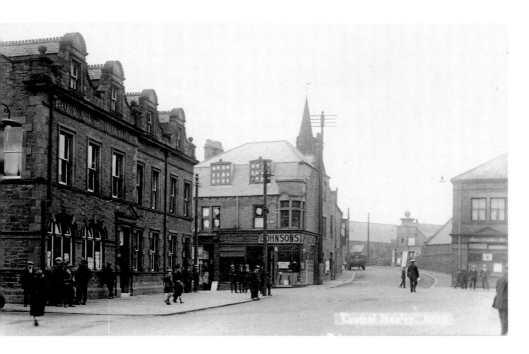

The Royal Hotel

The Royal Hotel, on the left, opened its doors to the public on 24 November 1898; it is still serving the public after 111 years. On the right can be seen a building with a stone ball on the top, this is the Empire Picture Hall which was destroyed by fire in 1927.

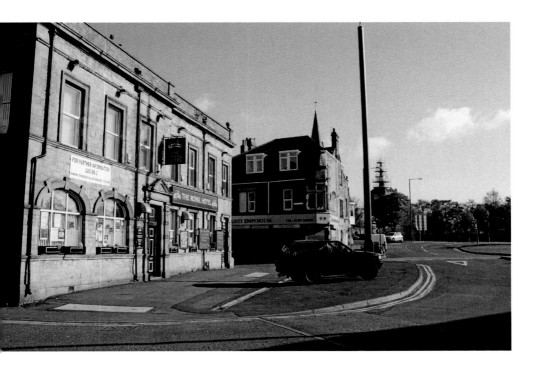

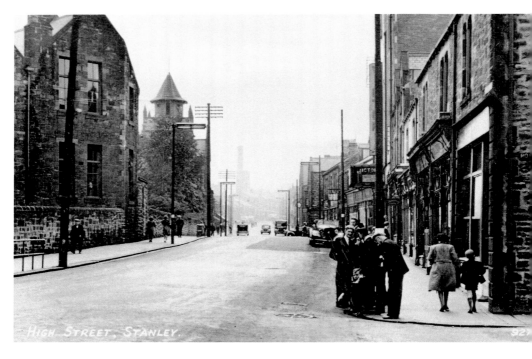

St Joseph's School

St Joseph's Catholic School, on the left, was erected in 1872 and enlarged three times between 1891 and 1908. As you can see by the scaffolding, once again work is being carried out.

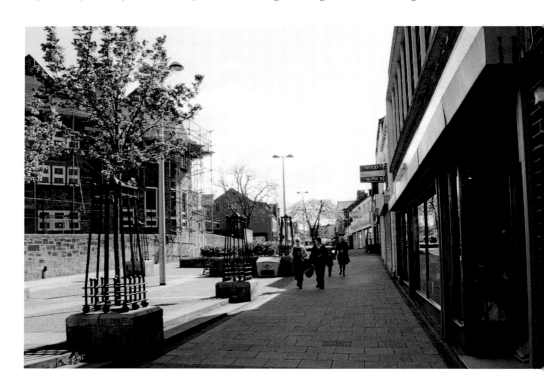

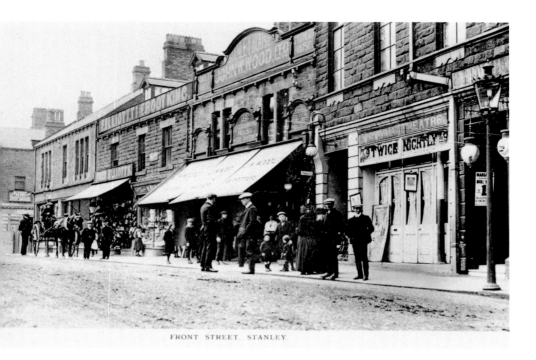

FRONT STREET, STANLEY

The Victoria Theatre

The Victoria Theatre opened on 29 June 1893. It was built by Mr T. C. Rawes of Consett, the first manager being M. H. Lindon. The theatre, originally intended as a public house, could not get a licence. The Havanna Court flats built in 1999 now occupy the site.

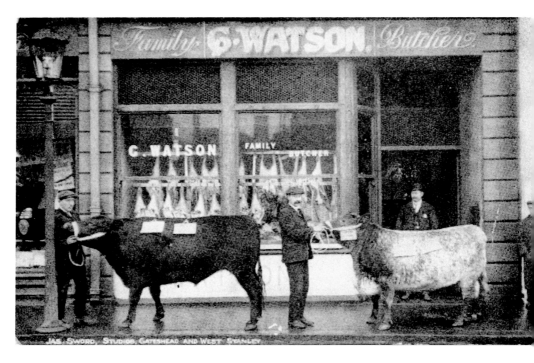

Forsters

At the turn of the twentieth century, butchers like Mr G. Watson would still be slaughtering their animals at the back of the shop. Today Forsters, who have had the butchers shop on Stanley Front Street for at least fifty years, have their meat delivered.

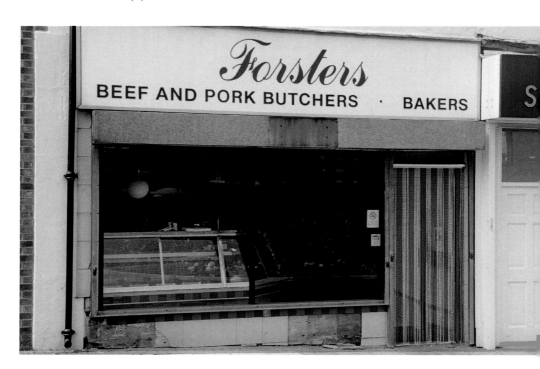

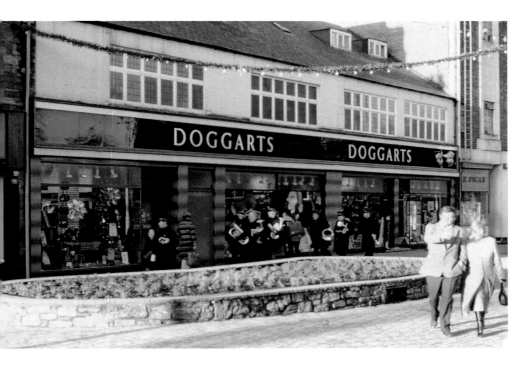

Doggarts

Doggarts, once a household name in Stanley, closed 23 December 1980. The premises had formally been a drapers shop owned by a Mr John Wood. As I write M & Co., seen here, are in the process of having a sale and the shop is up for let.

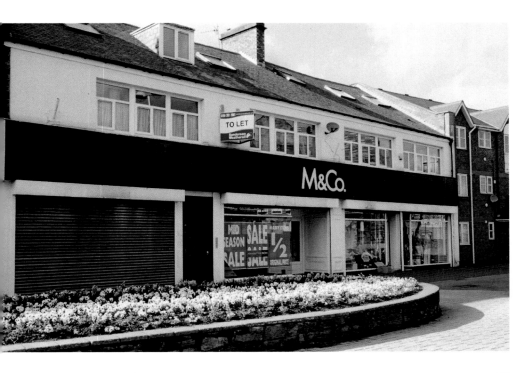

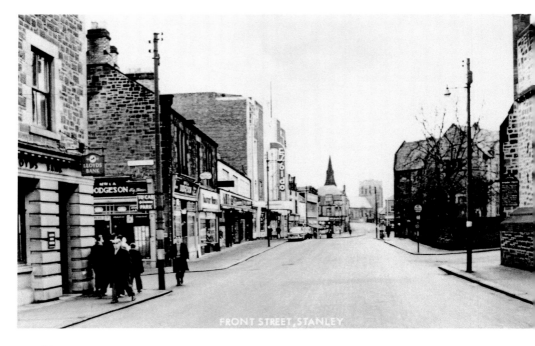

Essoldo

The old Victoria Theatre was demolished and the new Victoria cinema opened on 21 March 1935. The Victoria cinema would become the Essoldo in 1948 and in 1970 the Classic. The Classic closed in 1976, and in 1999 the building was demolished. One story I have been told as to how the Essoldo got its name is that it is named after the Christian names of the family who owned it, which were Esther, Solomon and Dorothy.

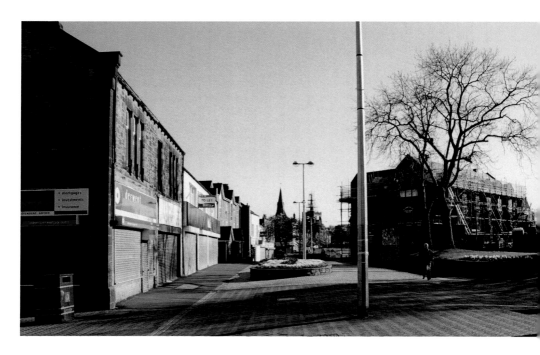

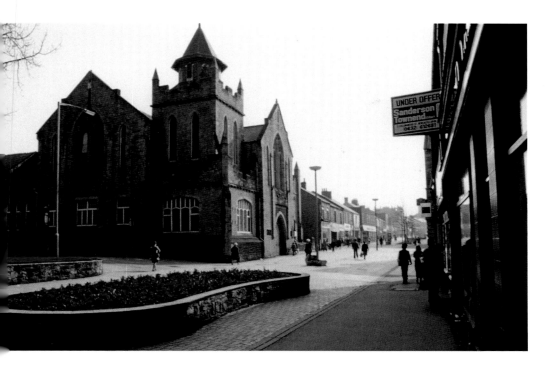

The Wesleyan Chapel

The first Wesleyan Chapel on this site, built in 1890, was found to be too small. The building seen here was built in 1899. It was noted for its beautiful acoustics and I can testify to that as I once sang here while I was a choirboy at Tanfield Church. The chapel was demolished at the end of 1983 and Stanley Job Centre was later built on the site.

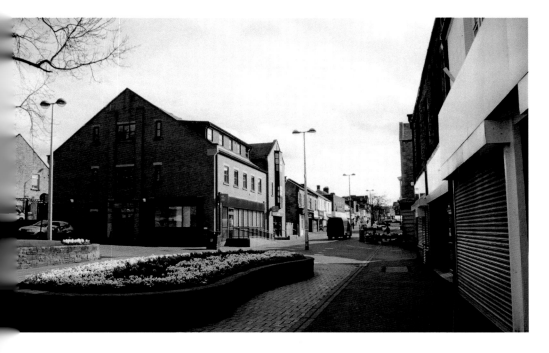

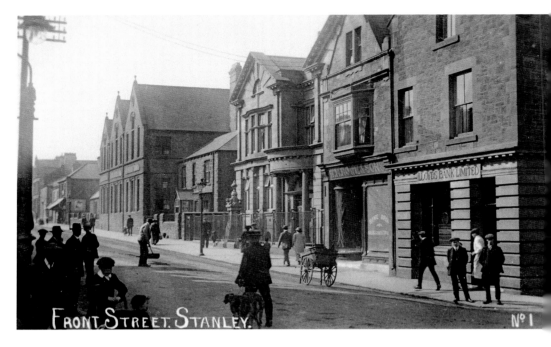

Lloyds Bank

Lloyds Bank, seen here on the right, stands on the site of a wooden shed that was a barbers shop owned by a Mr Witty. Time seems to have gone full circle, as the building has closed as a bank and is once again a hairdressing business.

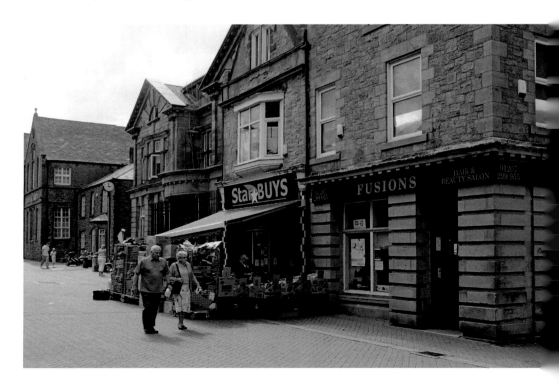

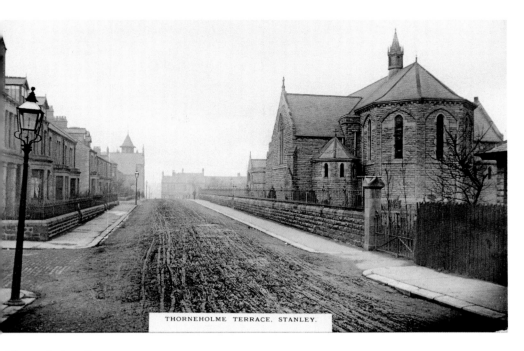

THORNEHOLME TERRACE, STANLEY.

Thorneholme Terrace

The only things to have changed in all the years since the old picture was taken are the road surface and the amount of cars now parked in the street.

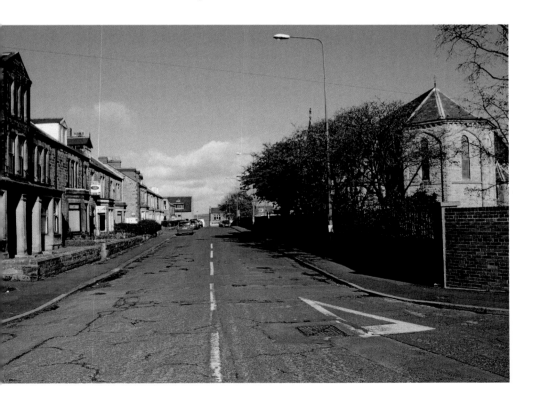

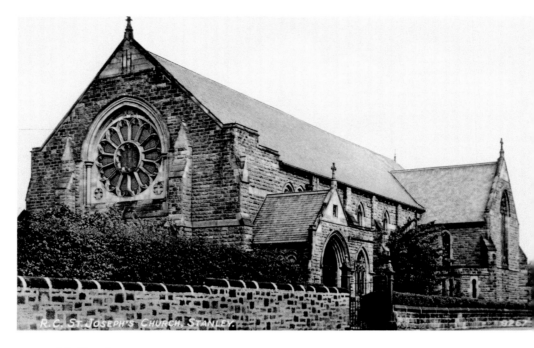

St Joseph's Church

St Joseph and the Sacred Heart is the Roman Catholic church of Stanley. It was built between 1899 and 1902 at a cost of around £7,000. It was enlarged in 1909 and can seat 650 people. It is said that the first service took place without a roof on the building. It is still a place of worship today.

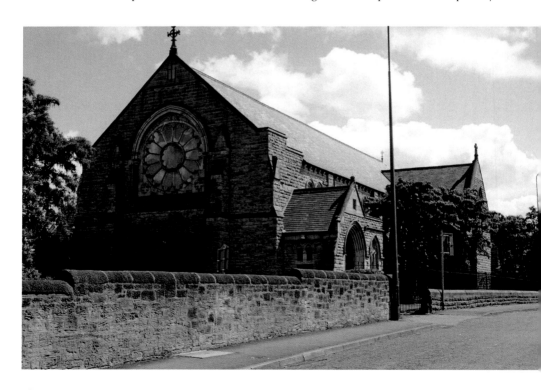

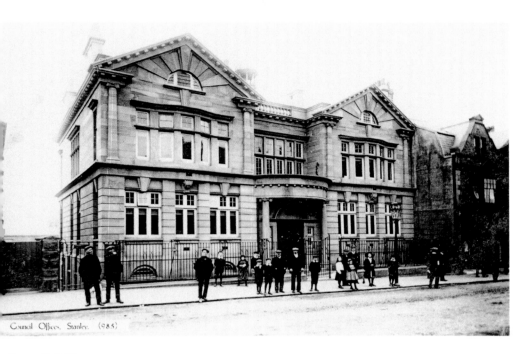

Council Offices, Stanley. (985)

Council Office

In 1892 when local government powers were first granted to Stanley District Council, the council rented premises in a building that stood on the site of what is now the Poundstretcher store. Later they moved to larger premises on the opposite side of the street. They moved to the building shown here in 1911, and it is still used as the Council Offices today.

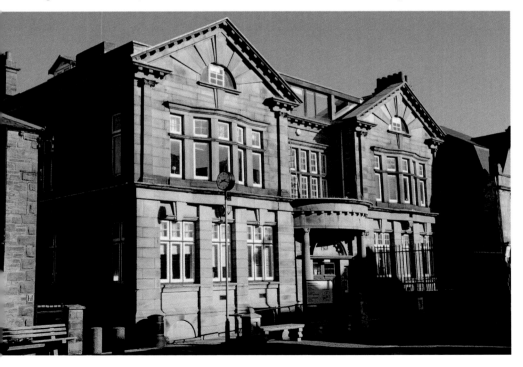

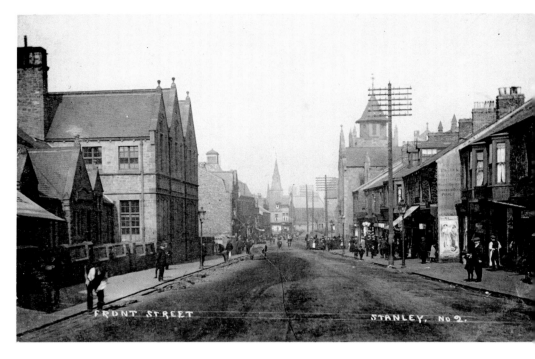

Front Street, Stanley

Stanley Board, or Central School, was opened in 1891 and was enlarged in 1897-98. Mr James Alderson was its first headmaster. The school closed many years ago and for a while the building was used as offices.

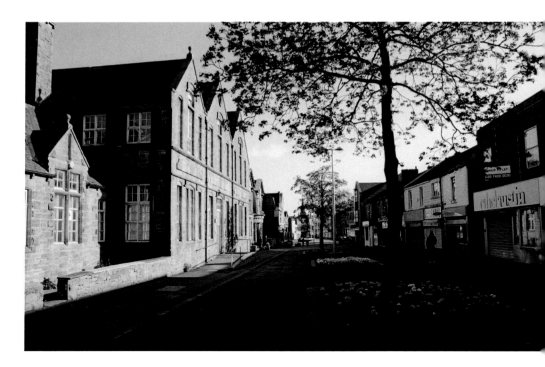

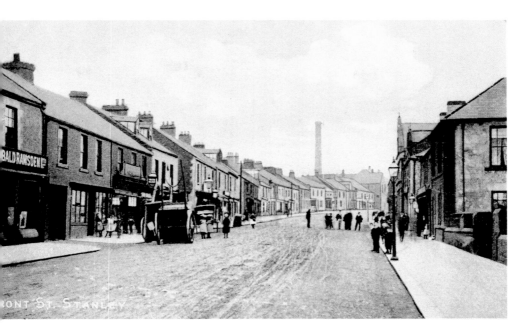

Front Street, Stanley

Most of the buildings on the left side of the street were built between 1880 and 1890. Archibald Ramsden opened his musical instrument shop on 18 May 1901. In 1881, Mr Benjamin Riddle had opened Stanley's first printing business on the premises. Today you can jet abroad after you have booked your holiday from one of the shops in the same street where foreign travel in bygone days would have been just a dream.

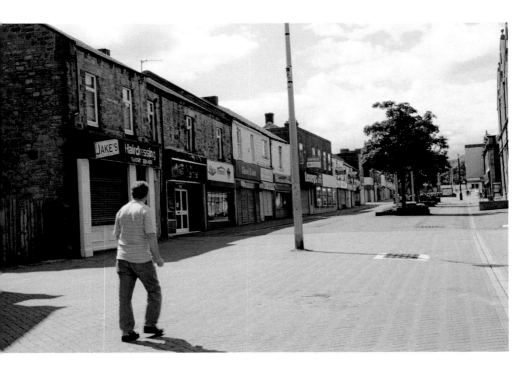

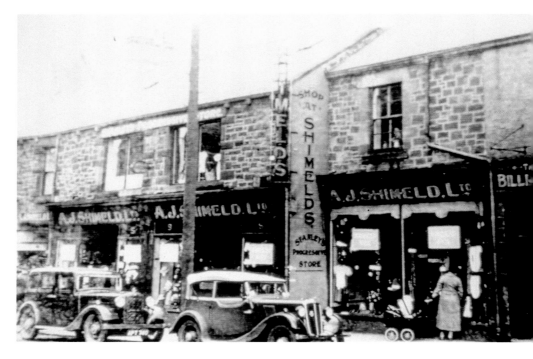

Shimelds Store

Shimelds store was still around when I was a young lad. We used to sing a verse in the song the Hokey Cokey that went 'Oh where do you get your Nylons — Shimelds!' Walter Wilson had a store on this site, which finally closed at 8 p.m., 8 March 1997. A branch of the Ethel Austin group took over the building but this has also closed down.

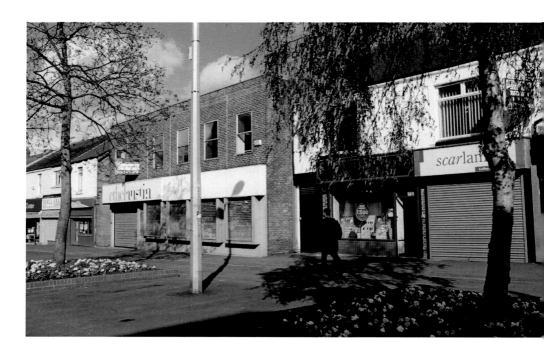

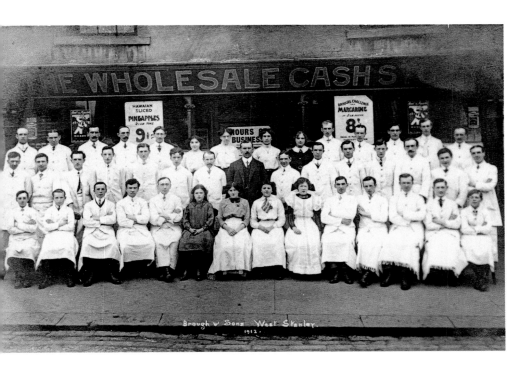

Broughs

Brough Wholesale Cashstore opened in Stanley c. 1905. This is a picture of the staff from the store in 1912. On a personal note, my mother used to work in the café of this store, not, I hasten to add, when this 1912 picture was taken but just before Lipton's took the store over. Lipton's store closed and after standing empty for a while, it is now occupied by a branch of The Original Factory Shop.

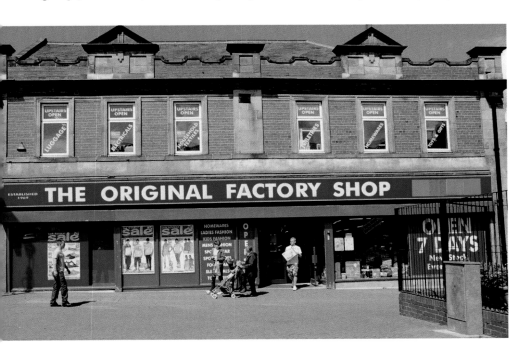

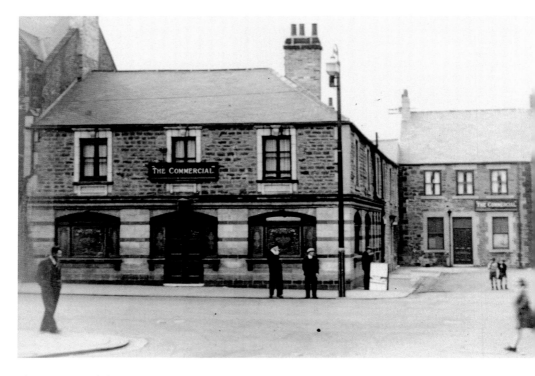

The Commercial

The Commercial was known locally as the Middle House or 'The Middles'. The earliest date that I have found for the building of this public house is 1879. An upstairs lounge was opened in 1940. Boots the chemist now stands on the site. Carlyons the florist shop, which is the small building on the right, is now closed.

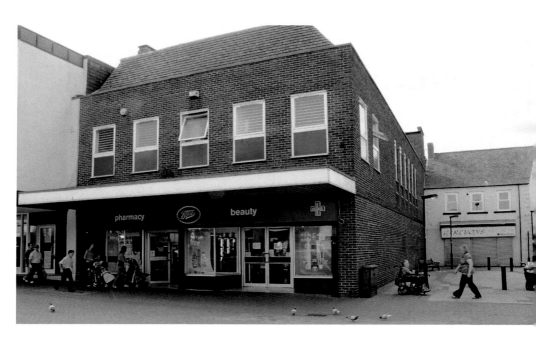

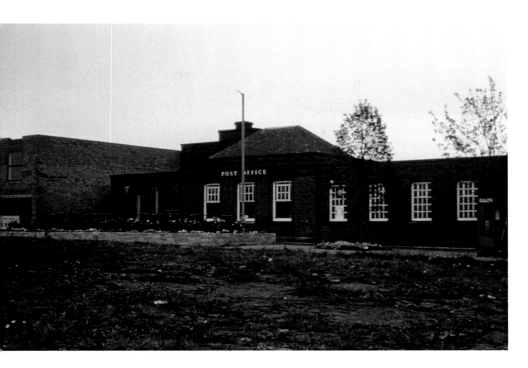

The Post Office

In 1935, the post office at the junction of Front Street and Station Road closed and the business was then transferred to this site. It then moved into part of the building belonging to Presto Supermarket, which was a little higher up Clifford Road. Presto's has since closed. On 30 March 1998 at 10 a.m., a new post office opened on Stanley Front Street. Bon Marché, Superdrug and Heron Frozen Foods have now opened shops in the old post office building.

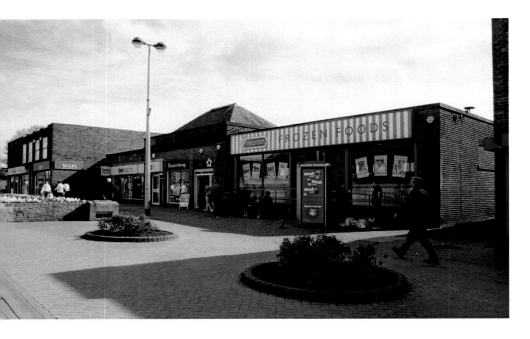

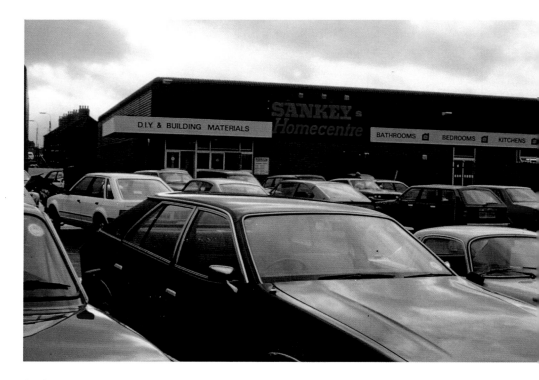

Sankeys

Sankeys DIY store opened its door at 10 a.m., 17 January 1981. Later it would become Texas DIY, and when Texas closed it would become Homebase DIY. Homebase closed in 2007 and the Argos Discount Store, which opened in September of the same year, now uses the building.

The Bus Station

When Stanley Front Street was made 'pedestrian only' in the early 1970s a bus station was built, opening in 1974. Depicted here is one of five murals that used to hang in this bus station. The bus station was demolished in 2005 and at present the site is used as a car park.

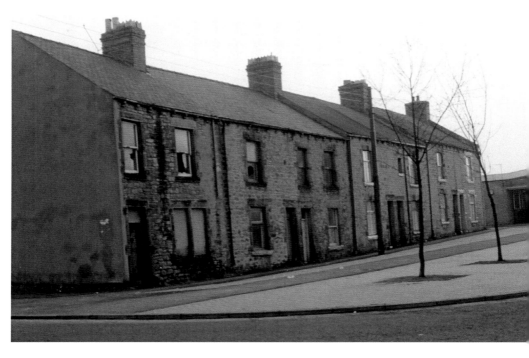

Mary Street

A view of Mary Street before it was demolished to make way for the new bus station, which was built between 2005 and 2006.

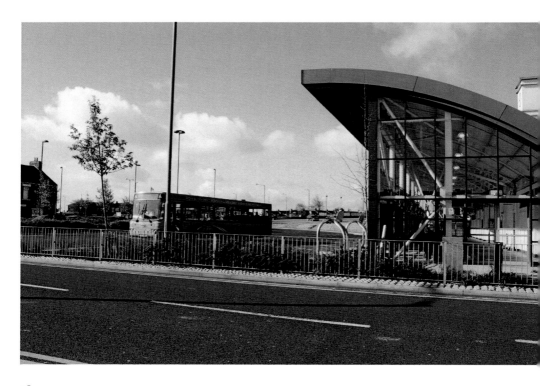

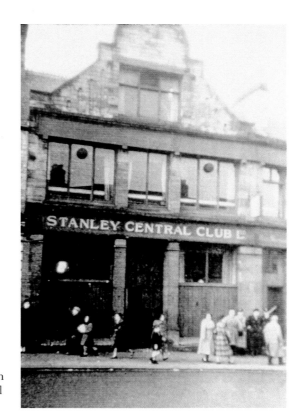

Stanley Central Club
This is Stanley Central Club as it was when it was in the middle of Stanley Front Street. It moved to new premises in Clifford Road in 1973, and the club is still a very active part of the community.

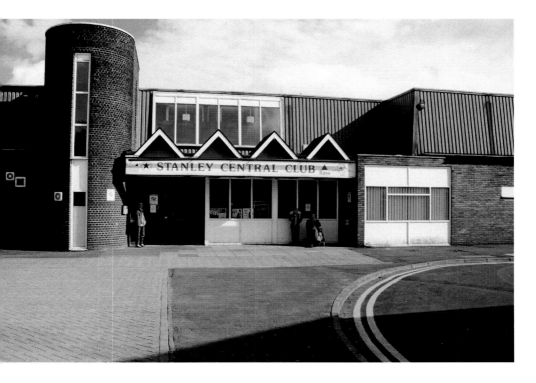

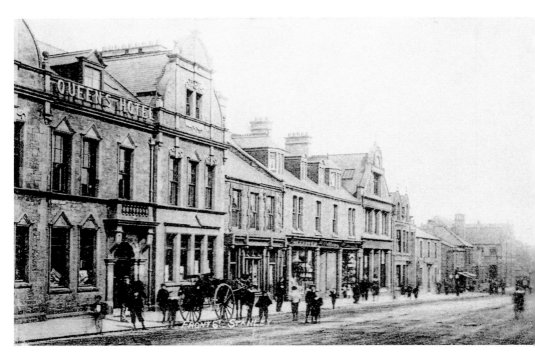

The Queen's Hotel

Built in 1898 this is the Queen's Hotel. It stood on the site of Chaytor's Buildings. One of the business premises in this building was let to Hodgkin, Barnett, Pease, Spence and Co. who were later to become Lloyds Bank Ltd. The Queen's Hotel was demolished in 1971, and a £-stretcher store now stands on the site.

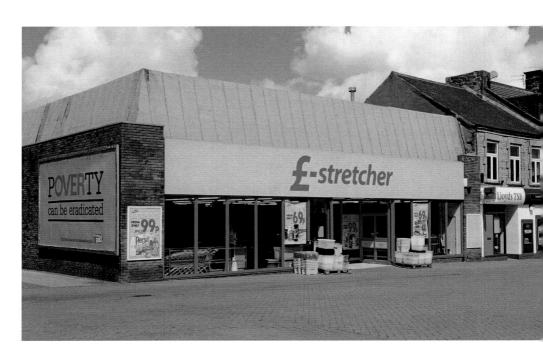

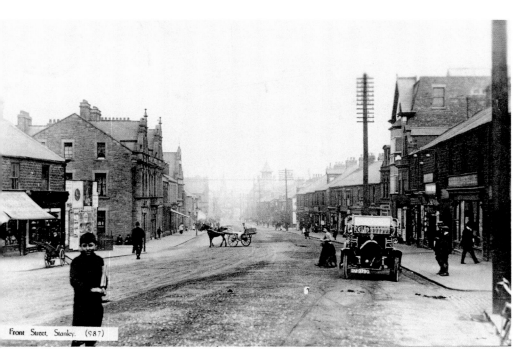

Front Street, Stanley. (987)

Slater & Costelloe

On the right of this postcard is Slater & Costelloe's Pawnshop, better known locally as 'Cossy's Pawnshop', with its three golden balls above the door. The pawnshop is long gone, but in these times of credit crunch how long before it is needed again?

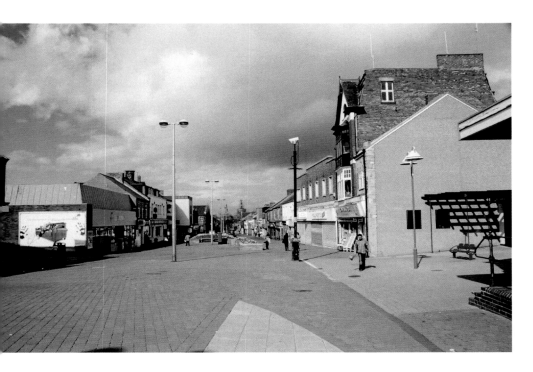

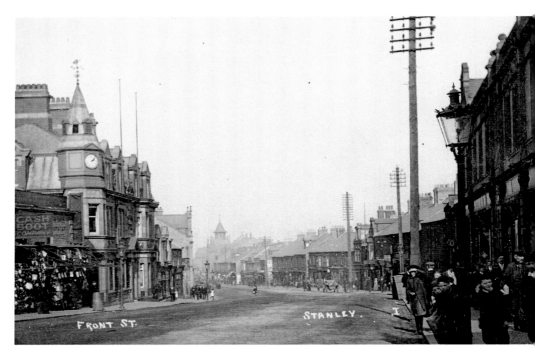

The Imperial Hotel

Built on the site of a butcher's in 1902, this is the Imperial Hotel, which was known locally as The Clock. The clock from which the hotel takes its nickname went missing for a time and has only recently being reinstated.

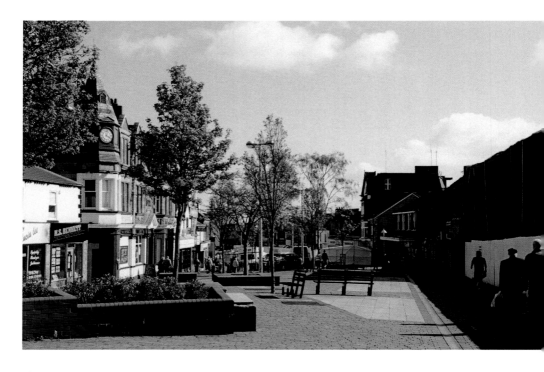

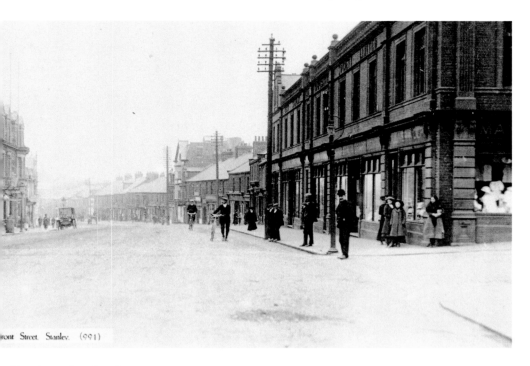

The West Stanley Co-op

The West Stanley Co-op was formed in March 1876. The first store was on the opposite side of the street to the buildings shown here. It moved to this side of the street in 1880 when a large general store was opened. A fire destroyed the building in 2008 and plans are under way to regenerate the area.

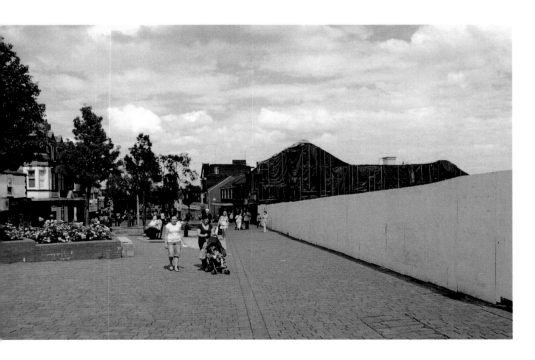

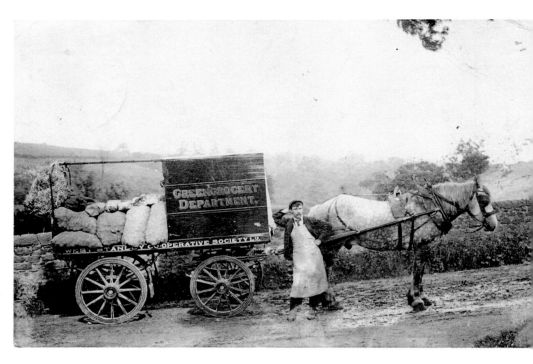

Co-op Transport

Co-op transport has improved considerably over the years. Here we see the West Stanley Co-op horse and cart delivering fruit and vegetables, while the modern day Co-op trailers collect their deliveries from a large distribution centre. The horse? Well, that was just tethered outside, and I don't think the Co-op use them for deliveries now!

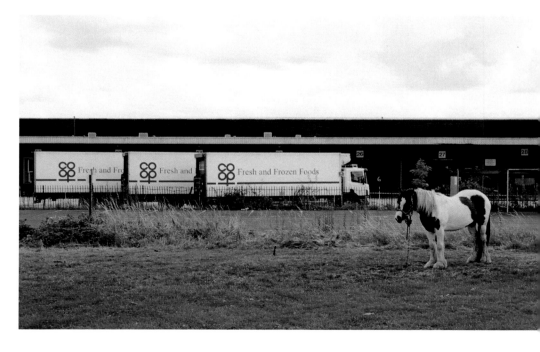

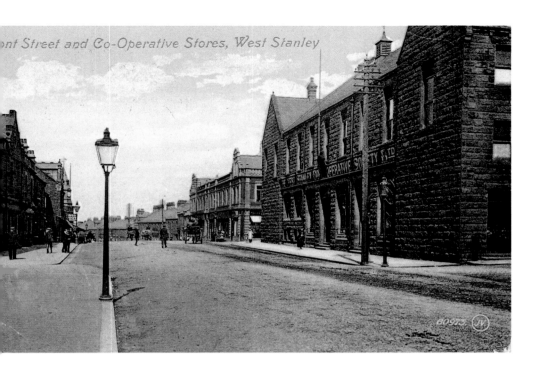

The Co-op, Stanley

The Co-op shops seen here were the central butchering and furnishing departments. The buildings further down the street also had clothing, drapery and jewellery departments. Above was a large hall, the first to be built in Stanley in which social events could be held. Once again, the Co-op is long gone and has been replaced with smaller retail outlets.

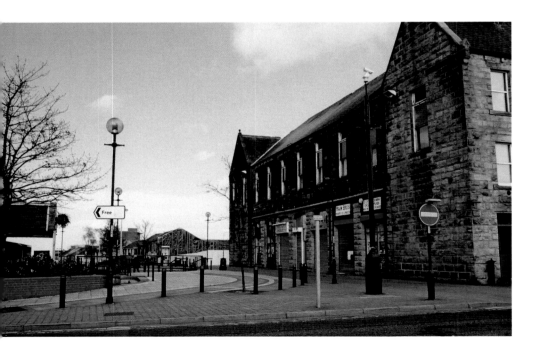

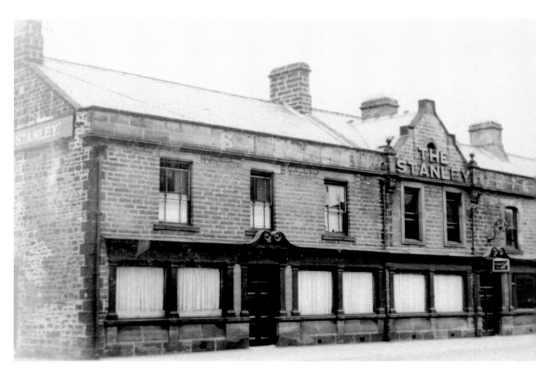

The Stanley Hotel

Built on a site called the Isle of Man in 1870, this is the Stanley Hotel or, as it was known locally, The Top House. It is now the Blue Boar Tavern and Montgomerys Nightclub.

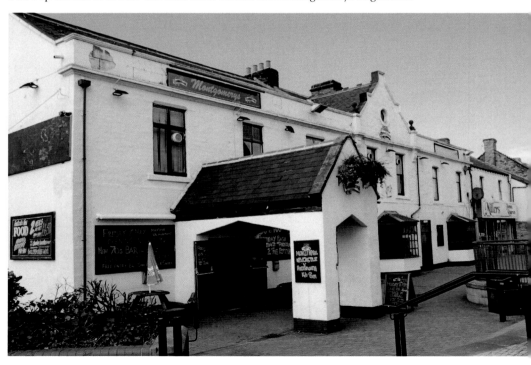

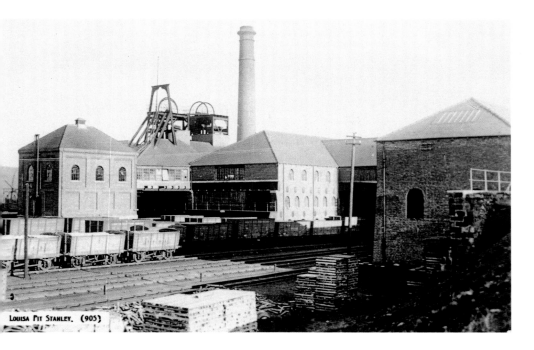

Louisa Pit Stanley. (905)

Louisa Colliery

The Louisa Colliery was sunk in 1863 and was named after the wife of William Bell, who along with William Hedley owned the pit. A second shaft, named the Shield Row or New Louisa shaft, was sunk in 1883. The last tub of coal was drawn from the colliery in 1956, and it finally closed in 1964. Fine Fare Supermarket, who had opened a store at the bottom of Stanley Front Street in 1961, needed larger premises and in 1977 they moved to this site. Asda now have a supermarket on the site.

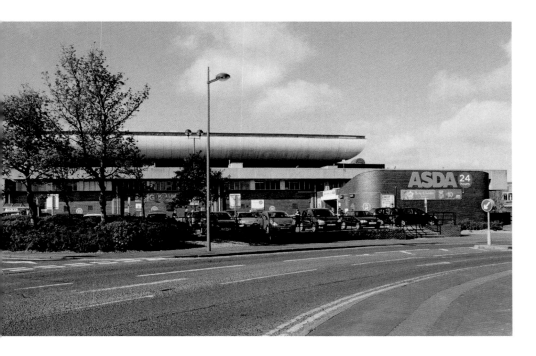

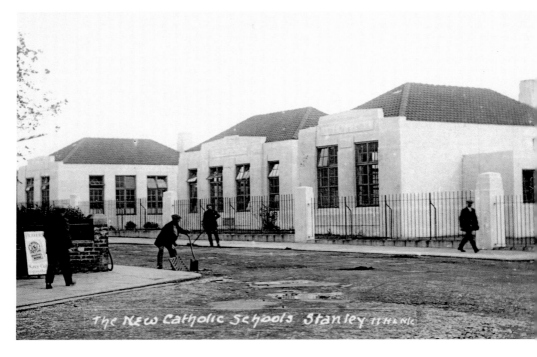

The New Catholic Schools Stanley 11H.Nc

Townley School

The White Elephant, as Townley School was known, opened in 1926. The school taught the Catholic children of the area for fifty years until it closed in 1976. The site was derelict for many years, until in 2006 the first houses were built. It has now become a housing estate.

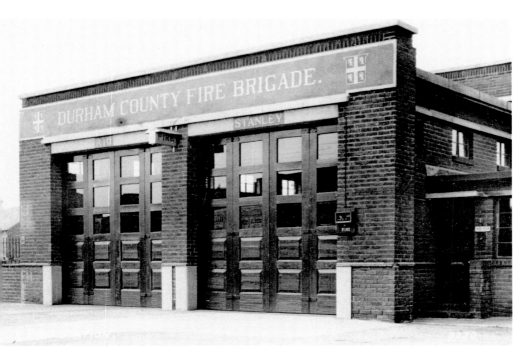

The Fire Station

The fire station we see here opened in 1941 but just twelve years later, in 1953, an extension was opened to meet the demands of an increasing population. Although the demand is still there, the fire station closed in 1997 (a new fire station has been built between Stanley and Chester-le-Street). Houses have been built on the original fire station site.

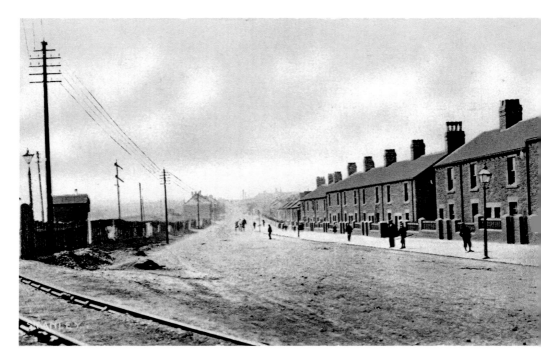

Louisa Terrace

Louisa Terrace, on the right, was built in 1867, but these houses were found to be too small so larger ones were built in 1894. The railway lines that can be seen formed part of a level crossing that was used up until 1934. Little has changed although a bypass now runs to the left of the picture.

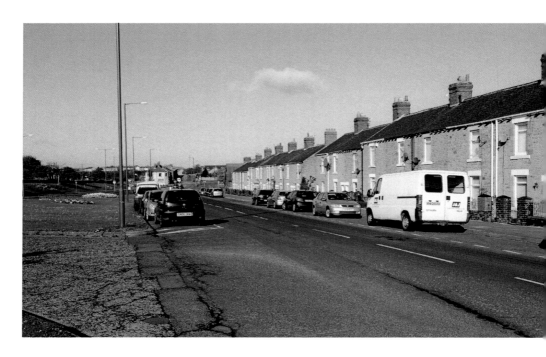

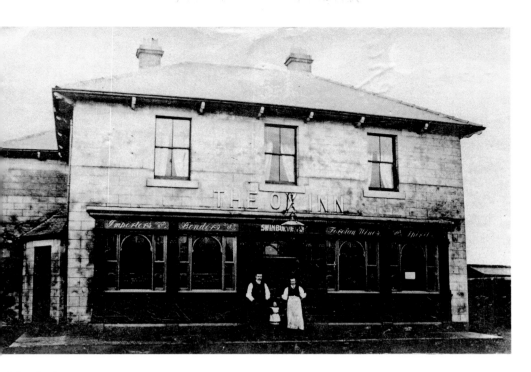

The Ox Inn

A public house known as the Bull Inn stood behind what is now the Ox Inn, but it was demolished when the Ox was built *c.* 1863. As you can see, the Ox has been extended several times over the years.

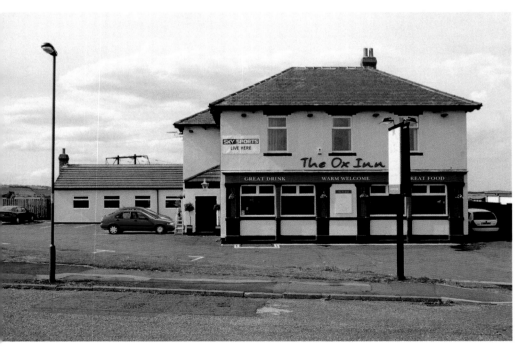

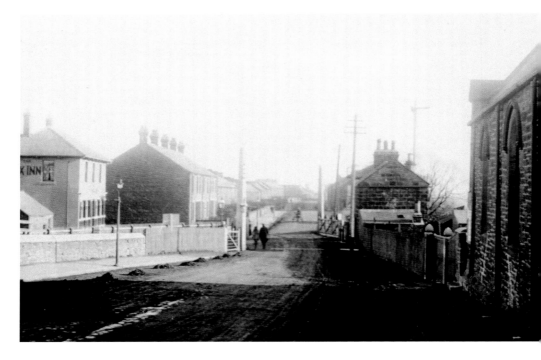

Level Crossings at Oxhill

This is the level crossing at Oxhill, and the picture was taken during a survey in 1921 of crossings between Chester-le-Street and Annfield Plain. The Ox Inn is on the left and Oxhill Methodist Chapel on the right. The crossings were dismantled many years ago and the chapel is now a private residence. Only the Ox Inn is left and even this has altered over the years.

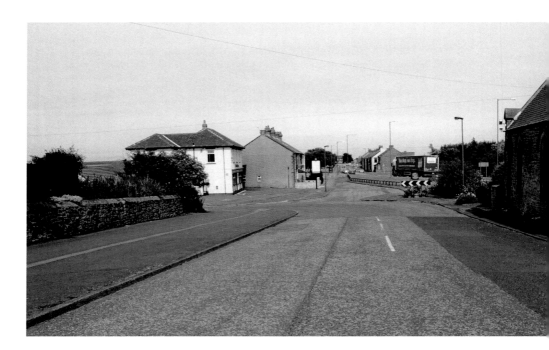

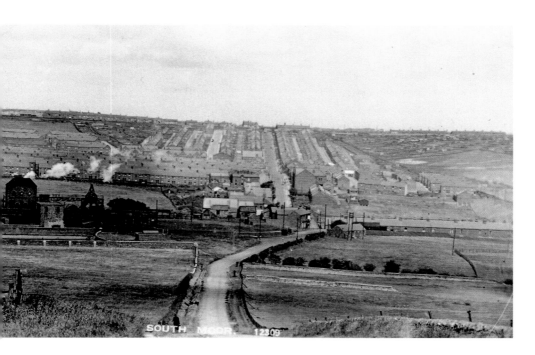

The Billy Pit

The West Craghead pit, or as it was later to become, the New South Moor pit, was sunk in 1839 with the first coals been drawn in 1841. When the Louisa pit opened in Stanley in 1863, the South Moor pit closed only to be reopened in 1898. It was then renamed the William pit after the owner William Hedley junior. From then on it was known as the Billy pit. After the pit closed, the site stood derelict for many years. Now a housing estate has been built on the site of this once productive pit.

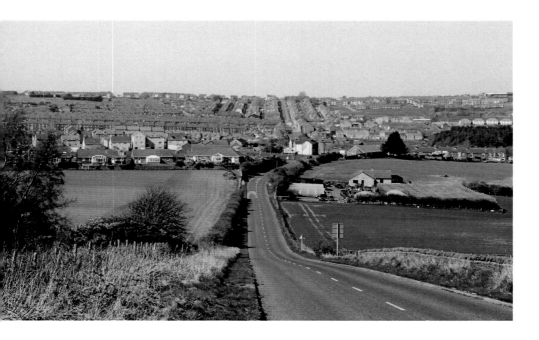

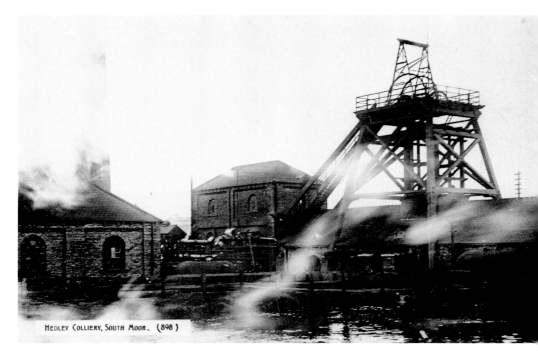

HEDLEY COLLIERY, SOUTH MOOR. (898)

The Hedley Pit

The Hedley pit, named after William Hedley senior, was sunk in 1885. The coals from this pit were taken to the Louisa pit in Stanley by an endless rope haulage system. The pit closed in 1946 but, as you can see, another type of energy can be found in the hills around South Moor, wind power. The wind turbines that stand not far from the site of the Hedley pit were erected in 2003.

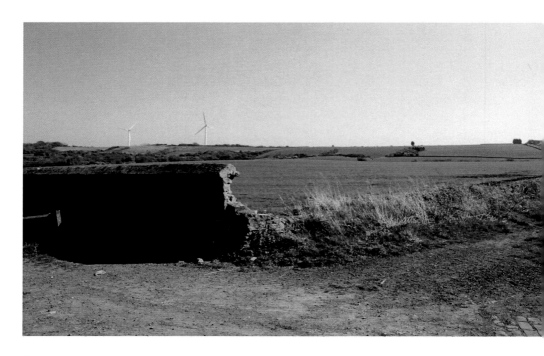

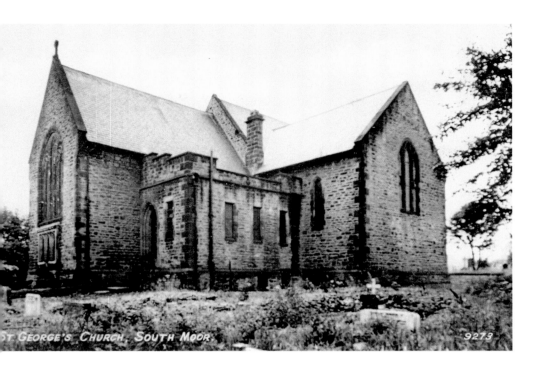

St George's Church

St George's church was where I was married, many moons ago. It has been the parish church of South Moor since 1912. The foundation stone was laid in 1897 and the church was dedicated 30 March 1898.

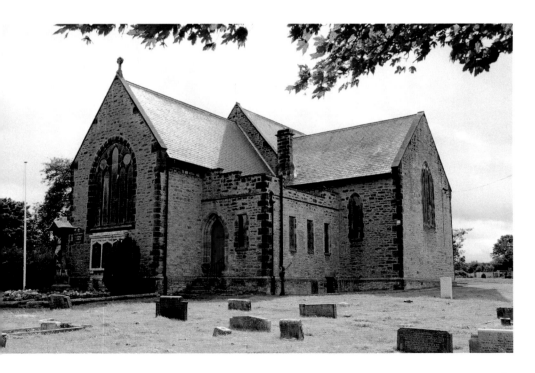

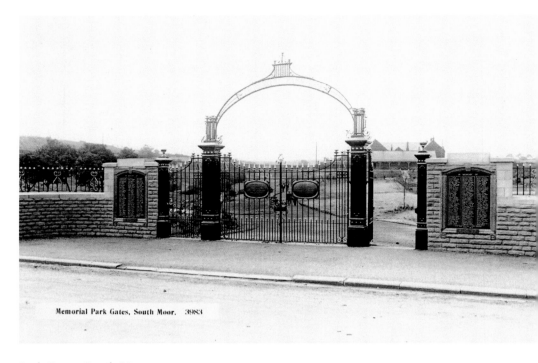

Memorial Park Gates, South Moor. 3983

Park Gates South Moor

The names of the employees of the South Moor Colliery Company who lost their lives in the First World War are inscribed on two tablets on either side of these gates. Two smaller tablets were added later to honour the residents of South Moor who lost their lives in the Second World War. Wreaths are still laid today in memory of the fallen.

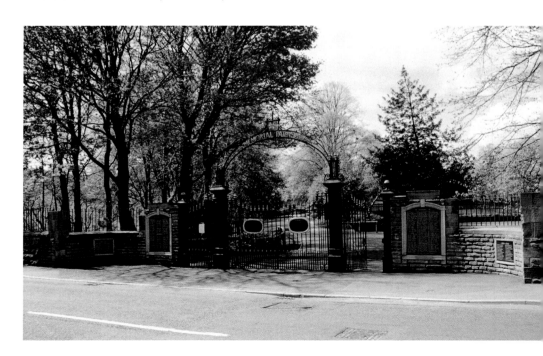

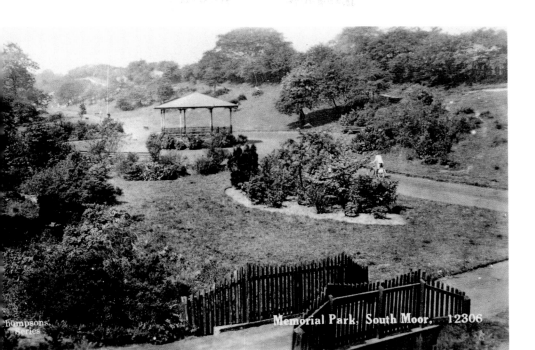

The Band Stand

The park, which was opened in 1920, had a bandstand in which the local colliery and military bands used to play. The bandstand was demolished many years ago and the only thing left visible was, for a time, the concrete base but now even this has been covered in vegetation.

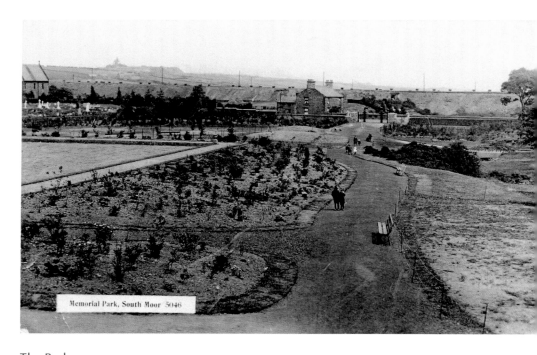

Memorial Park, South Moor 5046

The Park

The park had tennis courts for the energetic and bowling greens for those less so. Most of the park has fallen into disrepair but plans have now been passed to have the park improved and brought up to date with building of a multi-use games area and a skate park.

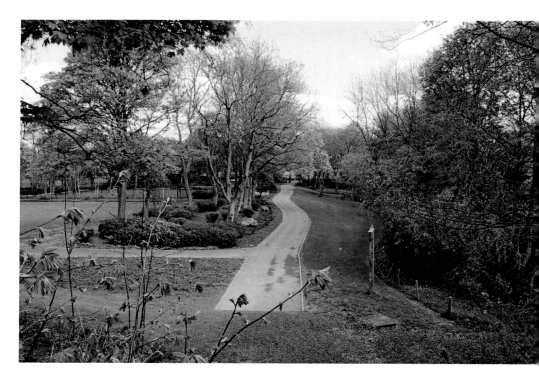

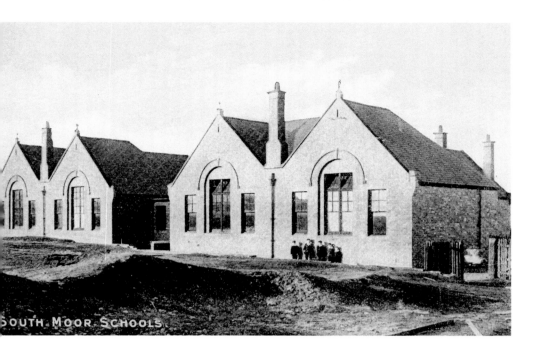

SOUTH MOOR SCHOOLS.

The School

The school, which was built and maintained by the South Moor Colliery Company, opened in 1901. It closed in 1948 after being damaged by colliery workings, and in 1951 it was demolished. A new housing estate has now been built on the site.

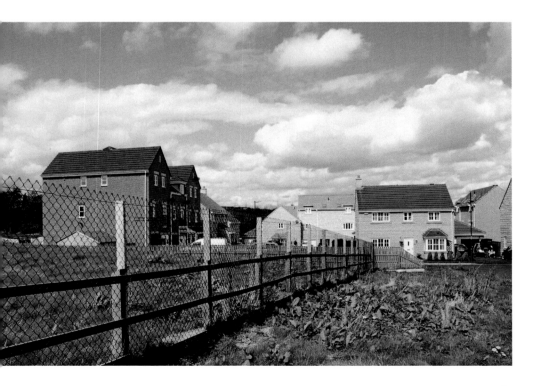

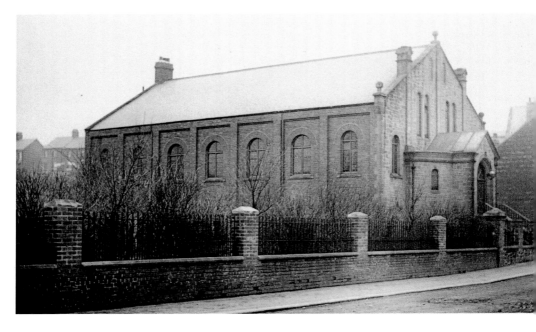

Miners Hall

Mr John Wilson M.P. opened South Moor Miners Hall in January 1898. It had reading rooms, games rooms and a library. The first moving picture show to be seen in South Moor was shown in this hall in 1901. It was also used for dances and concerts. After the mines closed, the hall was no longer used and stood empty for many years. It opened again as the Woodlands Tavern Banqueting Suite and became a popular place to have a meal.

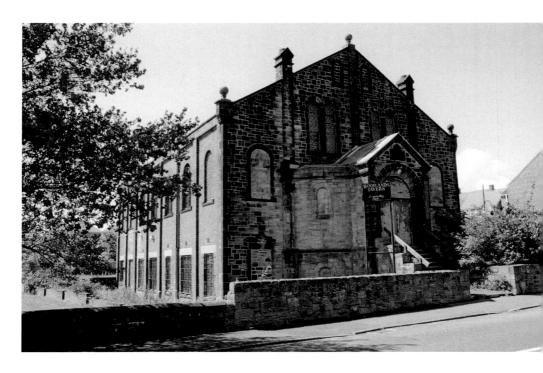

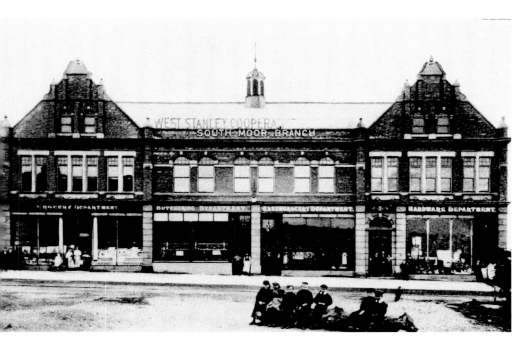

The South Moor Co-op

South Moor Co-op opened 18 August 1900. Its departments included grocery, butchery, green-grocery, boots and hardware. At the end of 1996, the building was demolished and the Hedley House flats were built on the site.

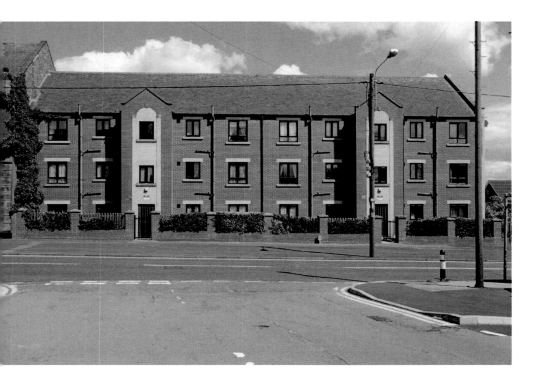

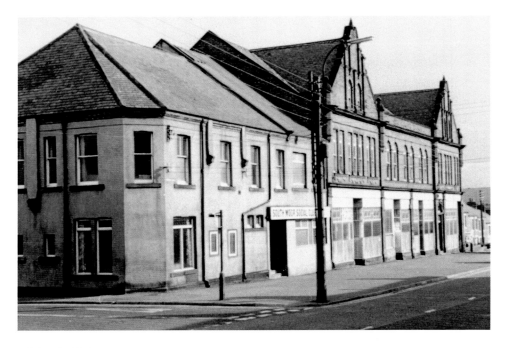

Mickey's Club

South Moor Social Club was always known as 'Mickey's Club' after its original owner Michael Martin. He owned a hardware shop and an off licence and built this building with the aim of getting a full license. He was turned down so he opened a private club, which was not successful. In 1904 a number of members of this club decided to form a working men's club and so leased the land and building. They later bought the premises. In 1955 it underwent major alterations. 1981 saw the club move to new premises in Charles Street, but due to dwindling membership the club closed around Christmas 2006. Now houses have been built on the Charles Street site.

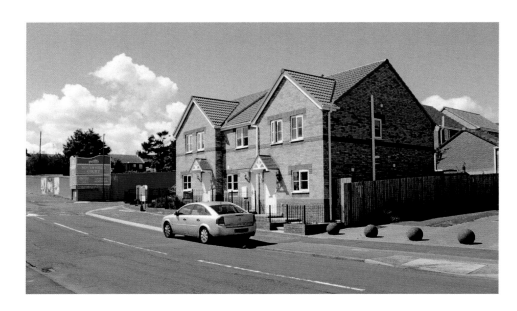

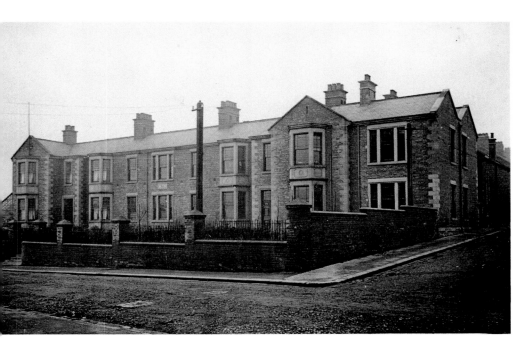

Colliery Offices

The first colliery offices were in the grounds of the Billy Pit. They were closed in 1906 when these offices were built. The colliery manager's house, The Limes, was part of the building and was said to have the first bathroom in South Moor. The offices were demolished and the site stood empty for a number of years. In 2004 building work started on the site, and now a new housing estate has emerged.

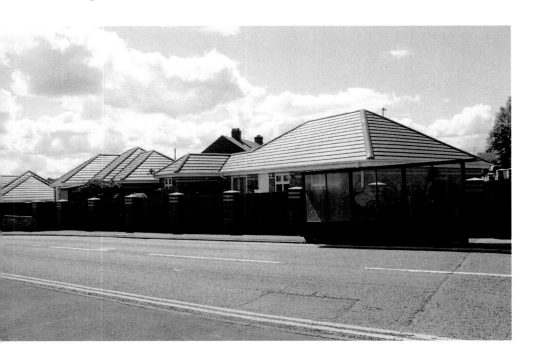

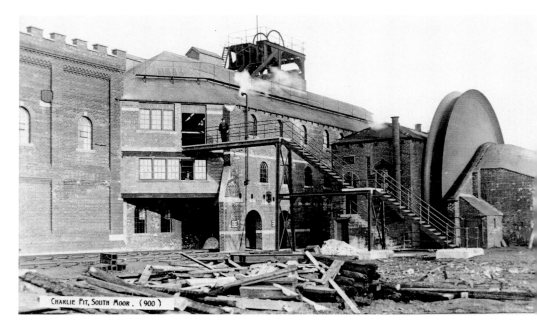

CHARLIE PIT, SOUTH MOOR. (900)

Charlie Pit

The New Shield Row, later Quaking Houses Pit, was sunk in 1845. The first coals had been drawn in 1846. Later still, it became known as the Charley Pit. The large wheel to the right is a Waddle fan that was used to ventilate the other collieries in the area. In 1908 the pit was modernised, but, like all the collieries in the area, it suffered from a lack of manpower during the First World War; in 1916 the Charley pit closed. The fan shaft remained in operation for a number of years after the pit's closure. Now only green fields and woodland are left to mark the spot where the colliery once stood.

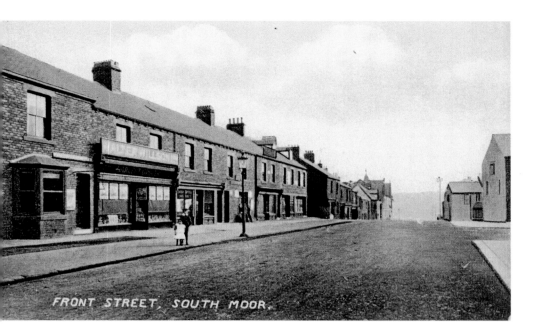

FRONT STREET, SOUTH MOOR.

Front Street

This is the street in which Michael Martin had his hardware shop and off license. Others shops included Walter Wilson grocers, a newsagents and drapers owned by Mr Davison and a greengrocers owned by Mr William Wright. One other notable shop owner was Mr Bainbridge, generally referred to as 'Sticky' because of his cork leg. It is claimed that he was the first man in South Moor to own a motorcar. The street still looks the same and, indeed, a newsagent is still there. Two hairdressing salons and a laundrette now occupy the other shops.

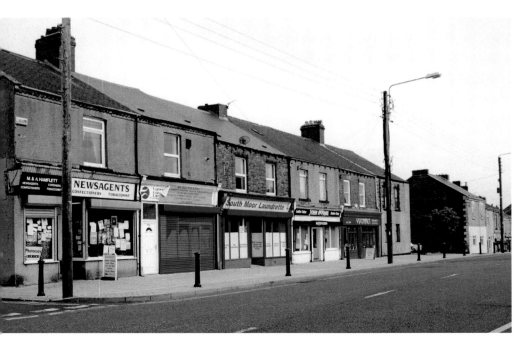

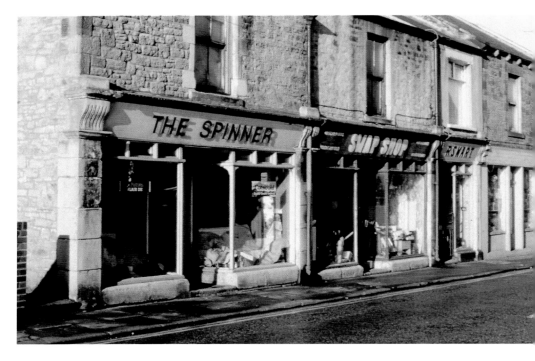

Swap Shop

The 'old' picture, which I took in the late 1970s, depicts some of the shops that were in the street at that time. Today the buildings are the same and only the products the shops sell differ.

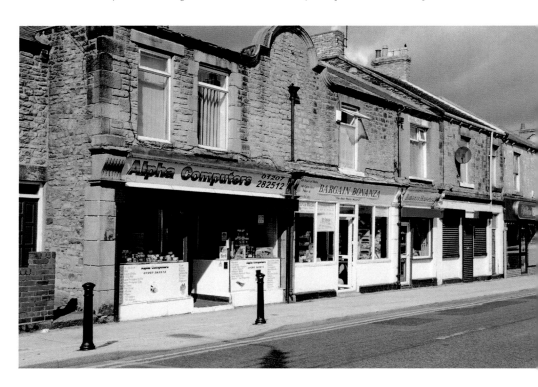

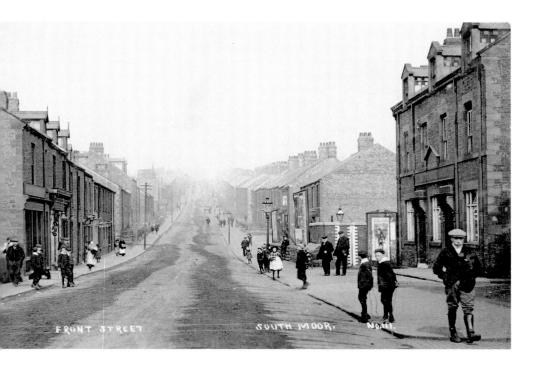

Park Road

Greenland Villas on the left were built in 1873. A little further on is a barbers shop owned by a Mr MacPhail. On the right can be seen a low wall with the white bricks, under this wall was a burn that ran down to Hustledown. It was on this site that the Arcadia cinema would be built in 1914. Greenland Villas and barbers shop have long gone and the Arcadia closed in 1962. The Arcadia building, however, still stands today and is now home to Little Acorns Day Nursery.

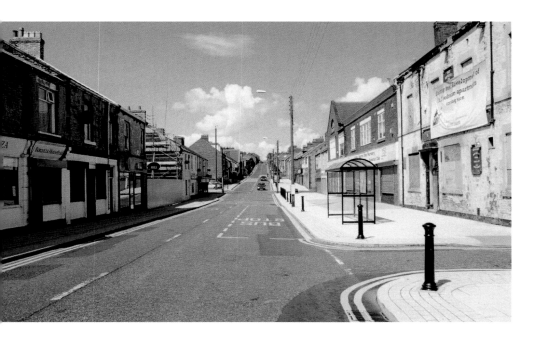

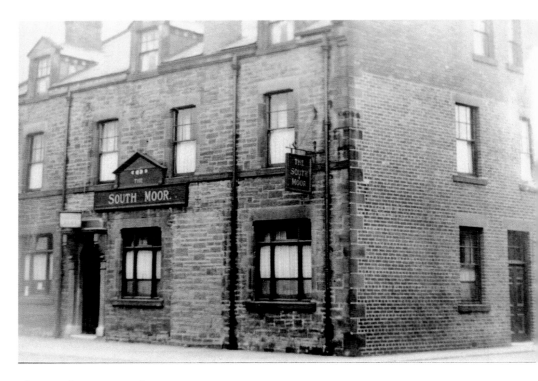

The South Moor Hotel

The South Moor Hotel, the license for which was transferred from the Oak Inn in old South Moor, was opened in 1897 by Mr Oxley. The Hotel was destroyed by a fire in 2005 and is still empty at the time of writing, but there are plans to build apartments on the site.

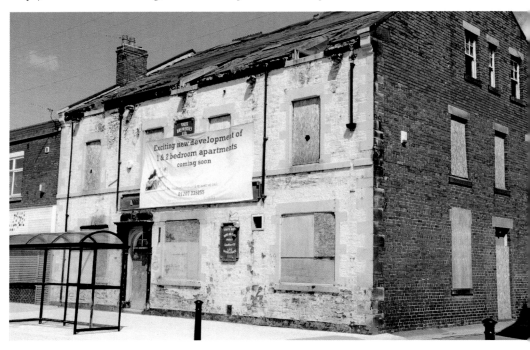

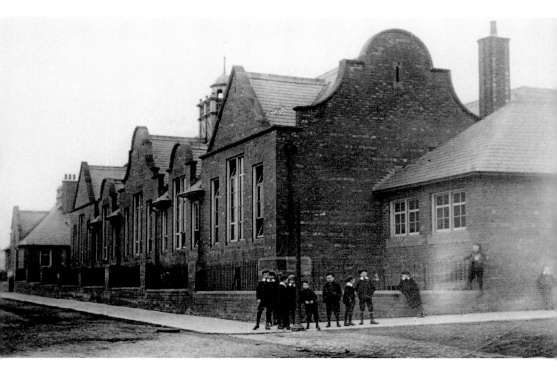

Greenland School

Greenland School, which took its name from Greenland Villas, was built in 1908. It has not changed in more than 100 years and the children of South Moor are still taught here.

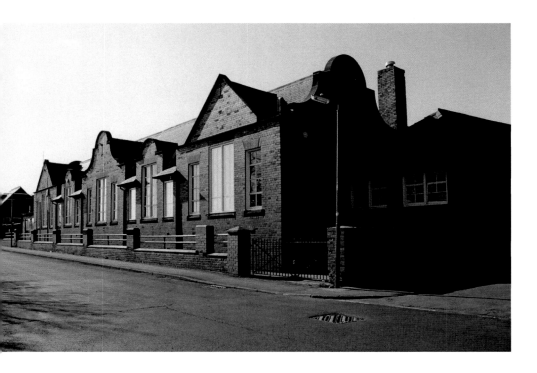

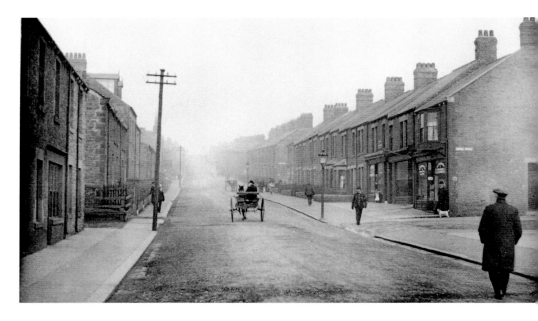

Tommy's Lonnen

Long before the houses, shown here, were built, the road to Stanley was a country lane bordered by trees and hedges. The lane at this time was called Tommy's Lane or Lonnen after Tommy Daglish who lived in Greenland Villas. Tommy had the sole rights to gather horse manure from this lane. The lane would later become South Moor Lane and after the Memorial Park was opened it was renamed Park Road. The road still bears that name and apart from the mode of transport, not a lot has changed.

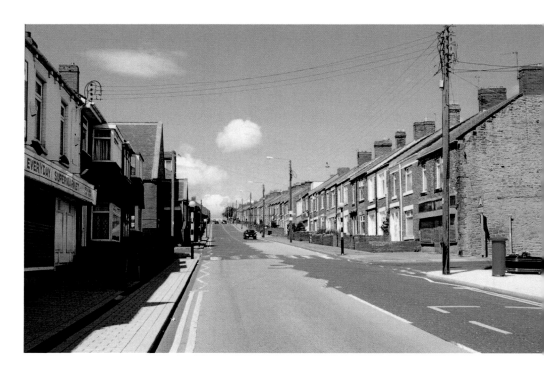

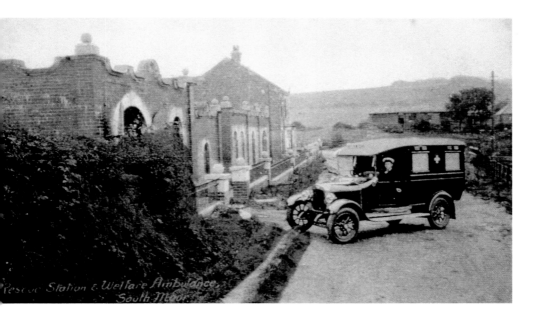

Mines Rescue Station

The 1911 Coal Mines Act made it the duty of coal owners to establish central rescue stations so that collieries were within a 10-mile radius of a station. This was later raised to a 15-mile radius. The Mines Rescue Station at South Moor was built between 1912 and 1913. Before the use of ambulances, injured miners were either taken home or to Newcastle Infirmary in horse-drawn carts. Miners had a greater chance of survival thanks to the introduction of ambulances. The building is no longer used as a rescue station, and it was, until recently, used as a boat-building yard, which was owned by Riva Boats.

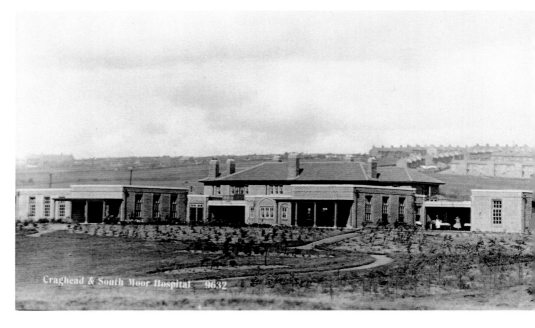

Craghead & South Moor Hospital 9632

South Moor Hospital

When the 1920 Coal Mines Act was passed which compelled coal owners to pay 1*d* per ton into a welfare fund for miners, it was proposed by the local lodges to use the money to build a hospital. Work started on the Holmside and South Moor Welfare Hospital in 1925 using bricks supplied by the South Moor Coal Company. The building was finished in 1926 and the official opening took place in 1927. The hospital was threatened with closure in the 1990s but these threats were not carried out until 2008 when the wards closed and the building was demolished.

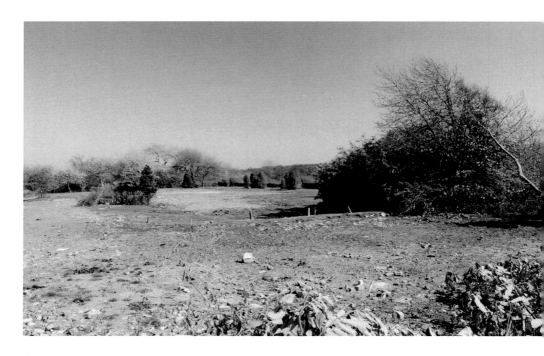

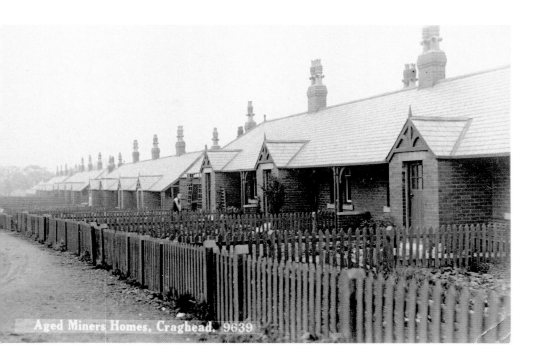

Aged Miners Homes, Craghead. 9639

Craghead Miners' Cottage

The Craghead Aged Miners' Homes were built for the miners of Craghead in the 1920s. They have not changed much during the intervening years.

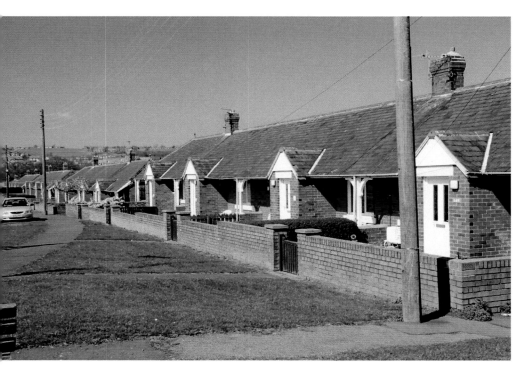

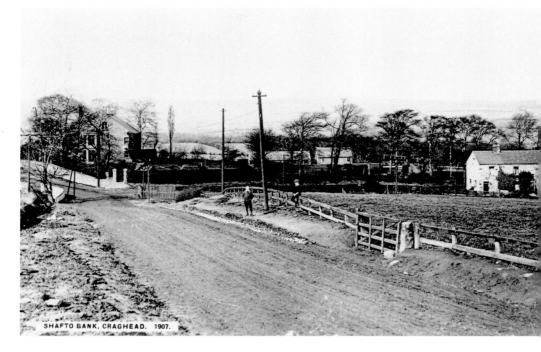

SHAFTO BANK, CRAGHEAD. 1907.

Shafto Bank

Shafto House, at the bottom of the bank on the left, was where the Hedley family lived *c.* 1850. At the side of Shafto Cottages, on the right of the picture, was a doctor's surgery. The surgery may no longer be used but the cottages are still there.

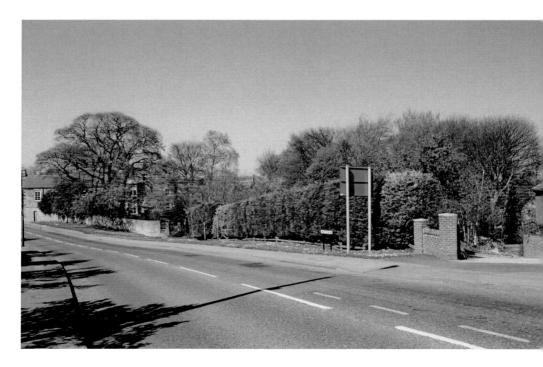

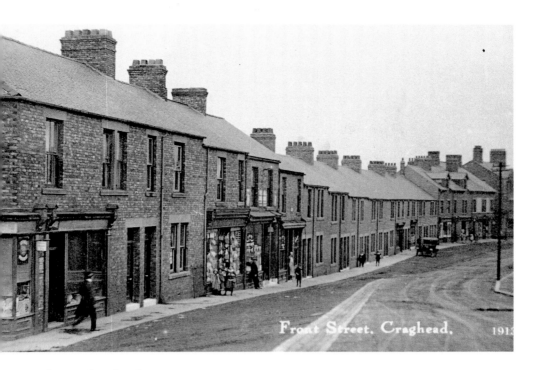

Front Street, Craghead

With shops such as a newsagent, grocer, butcher and general dealer, the Craghead Front Street of around 1916 is not so very different to the Craghead Front Street of today.

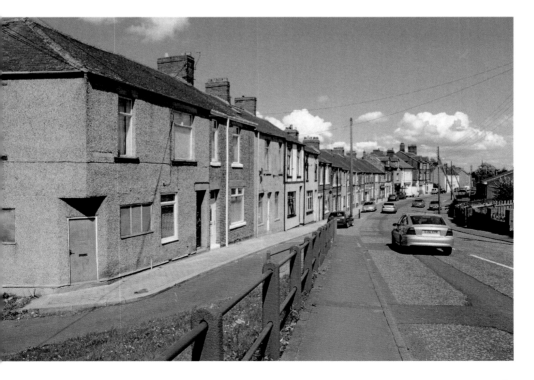

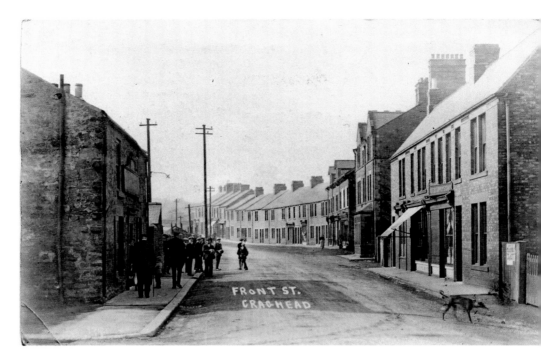

The John Castle Inn

On the left is the John Castle Inn known as 'the Jerry' because at one time it only had a licence to sell beer. It is still selling beer, and is still known as the Jerry, but today it can also sell wines and spirits. On the right is the Craghead Hotel, now home to Graphic Print.

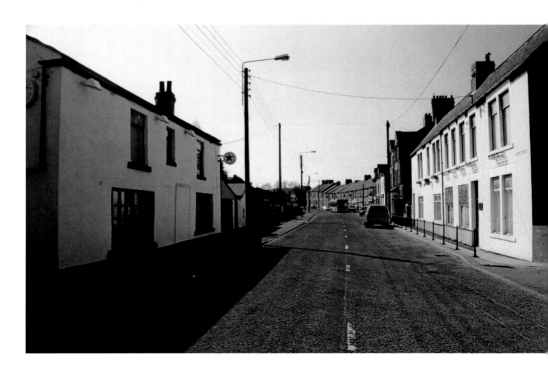

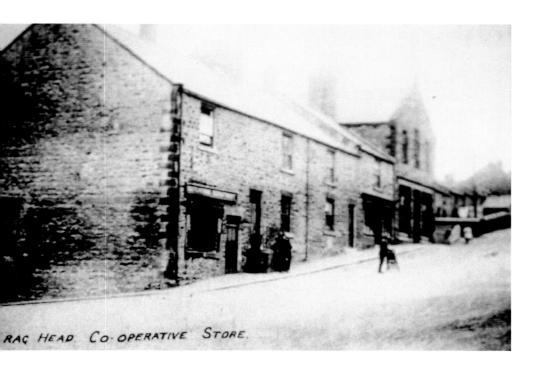

RAG HEAD. CO-OPERATIVE STORE.

Craghead Co-op

Craghead and Holmside Co-operative and Industrial Society was formed in 1883; by 1887 it had five departments selling goods, grocery, drapery, hardware, ironmongery and boots and shoes. Above the store were the reading room and a large meeting hall. The Co-op building was demolished around 1992 and the area was landscaped.

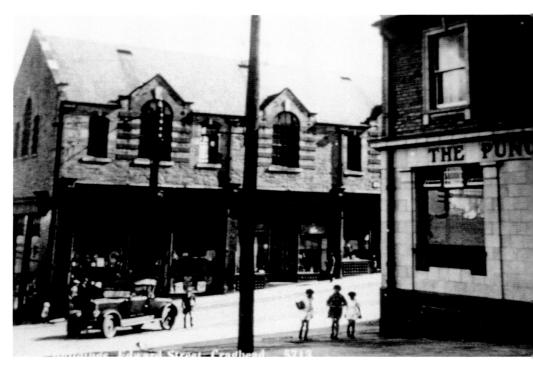

The Punch Bowl

The Punch Bowl public house on the corner of Thomas Street and Edward Street was at one time a lot smaller than the one seen in these two pictures. It was built onto the side of a house but has been modernised over the years.

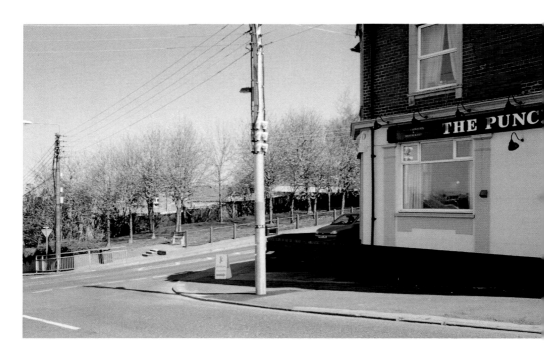

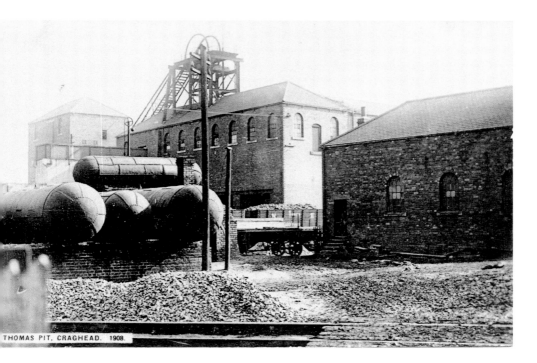

THOMAS PIT. CRAGHEAD. 1908.

Thomas Pit, Craghead

The Thomas pit, sunk in 1841, was the second of six shafts to be sunk in Craghead. The others were the William in 1839, the George in 1854, the Oswald in 1878, the Edward in 1909 and the Busty in 1916. Now, sadly, none remain. The last pit closed in 1968 and some of the buildings form what is now Craghead Industrial Estate.

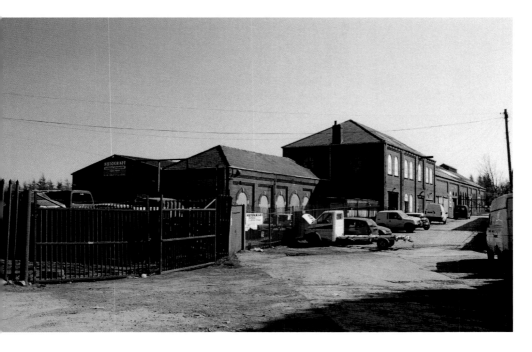

The Red Hut

The old village hall at Craghead was built in the 1930s and all sorts of events were held here. During the 1970s the hall was in need of a lick of paint. The paint donated happened to be red and so the hall was painted in this colour. From then on, the hall became know as The Red Hut. As the years passed, the hall became difficult to maintain and it was decided a new hall was needed. After a lot of hard work, grants were obtained and on 25 November 2000 the new Craghead Village Hall was opened.

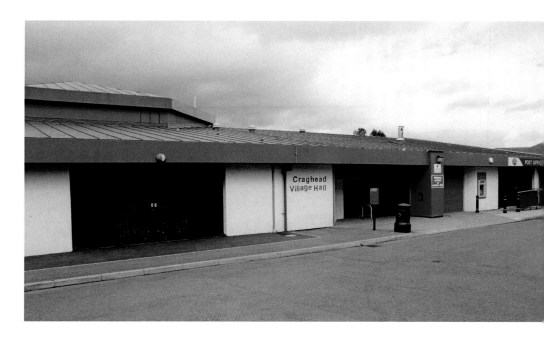

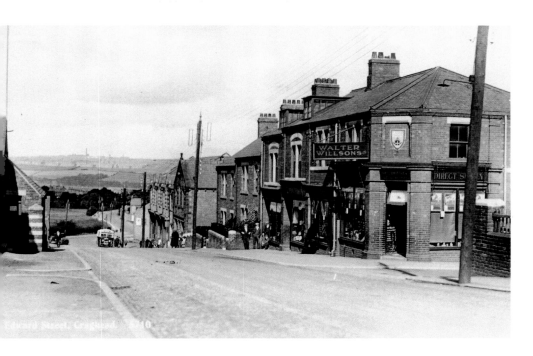

Walter Wilson

Walter Wilson had stores in a lot of the towns and villages throughout the North East and here we see one in Craghead. Walter Wilson's closed many years ago and the premises have been used for a number of different businesses including a library, pet shop, hairdressing salon and taxi rank. Today it is a private residence and here we see the owners outside.

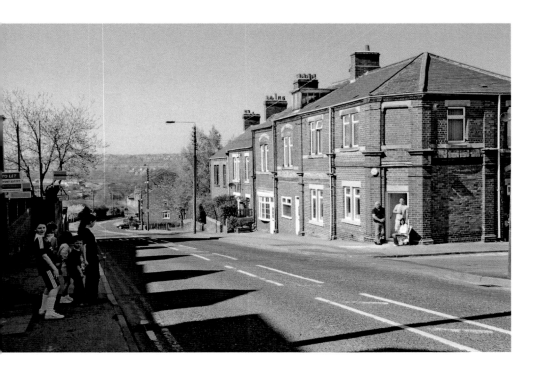

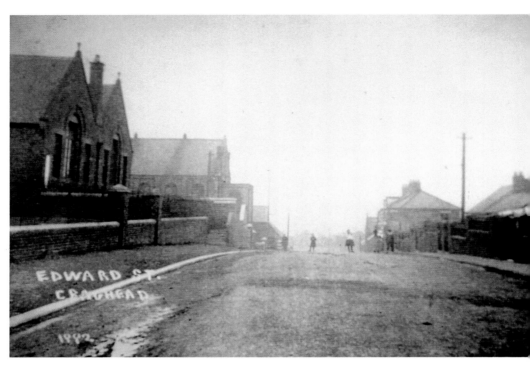

Craghead School

William Hedley (junior) built the Hedley Memorial School in 1887 and the Hedley Memorial Hall in 1902. Sadly, both have been demolished. On the site of the hall now stand houses and the school site is earmarked for development.

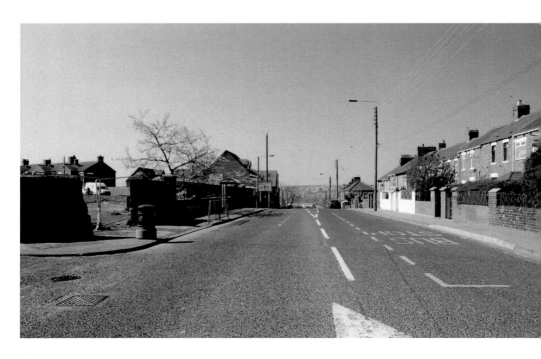

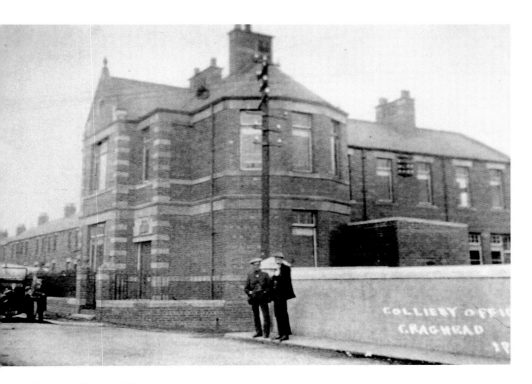

Craghead Colliery Offices

The Colliery offices stood at the top of the 'Store Bank' and served the pits in the area. With the closure of the pits, the offices were no longer needed and so were demolished and houses built.

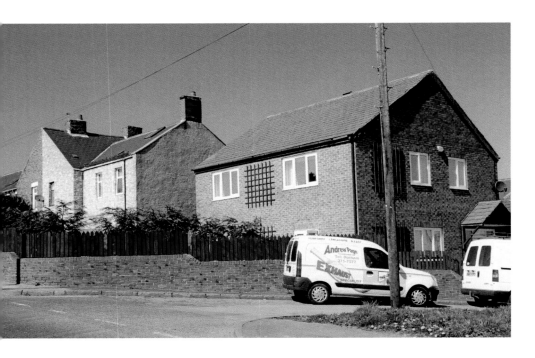

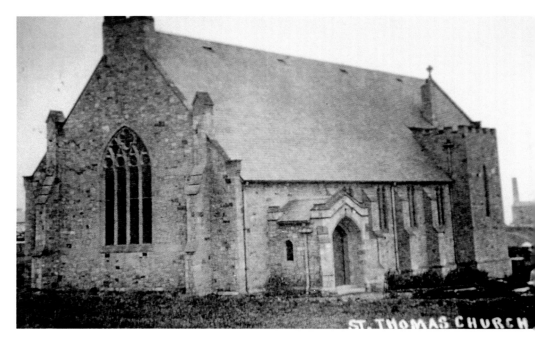

Craghead Church

St Thomas' Church of England church was built in 1914. Although the church may be closed for worship, the building remains.

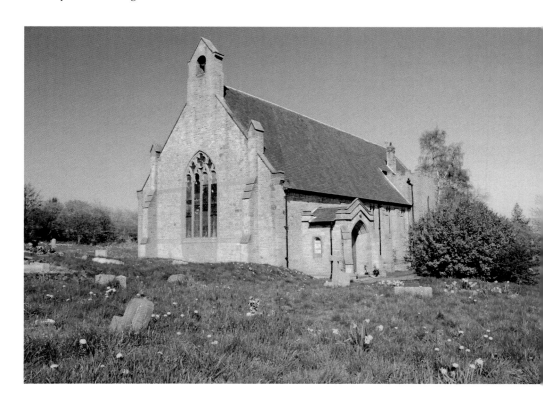

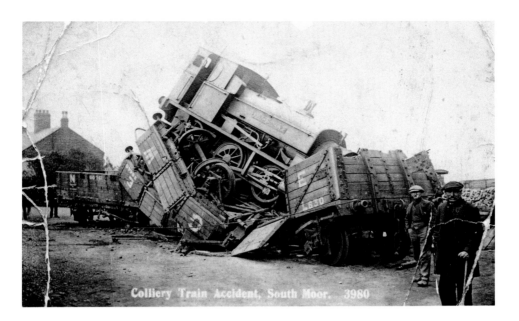

Colliery Train Accident, South Moor. 3980

The South Moor Mishap

The Colliery Train accident depicted in this battered old postcard is known locally as The South Moor Mishap. South Moor No.2 engine went over the top of the coal depot at South Moor on Derby Day 5th June 1920. It fell 25 feet to the ground but neither the driver, James Brown, nor the fireman, Joseph Graham, was badly hurt. The engine was repaired at Hawthorne Leslie on Tyneside and was soon put back into service.

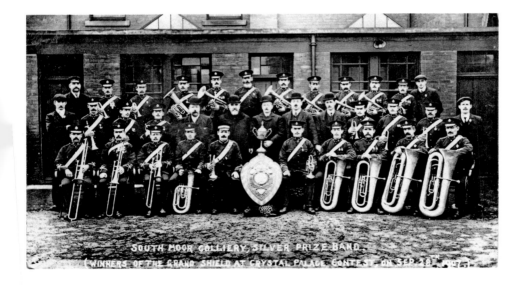

SOUTH MOOR COLLIERY SILVER PRIZE BAND.
WINNERS OF THE GRAND SHIELD AT CRYSTAL PALACE CONTEST ON SEP.

South Moor Colliery Band

South Moor Brass Band was formed in the 1890s. Mr Gus Haigh was appointed bandmaster in 1906 and by 1907, as this old postcard shows, they had won the Grand Shield at Crystal Palace. Right up until the start of the 1939-45 War the band were regarded as one of the best in the country.

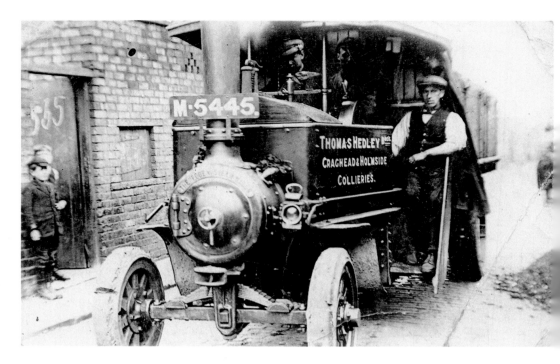

Coal Delivery

Coal deliveries were a common occurrence in the villages around Craghead. Coal was used not only to heat the house but also for washing and baking. Now that gas and electricity are used for heating, washing and baking, coal deliveries are now an increasingly rare sight.

Acknowledgements

Many thanks must go to John Shaw for correcting my mistakes.

The books by Jack Hair (thanks Jack) and Fred Wade have been a great help, as have *A History of Craghead* by J. Hall, *Craghead Past and Present* by Dorothy A. Rand and George Nairn, *Banners of the Durham Coalfield* by Norman Emery, *The Collieries Of Durham Volume 2* by David Temple and *Kelly's Durham Directory* of 1910.

Finally, yet most importantly, a big thank you to my wife, who pushed me into getting this book finished.